CURRICULUM ISSUES IN ARTS EDUCATION

VOLUME 1

THE ARTS
AND
PERSONAL GROWTH

Other Pergamon titles of interest

M. BLOOMER & K. SHAW
The Challenge of Educational Change

S. HECK & J. P. COBES
All the Classroom is a Stage

D. B. KEAT
Multimodal Therapy with Children

G. D. PALLETT
Modern Educational Gymnastics

P. RITTER
Educreation and Feedback

A related journal*

CHILDREN AND YOUTH SERVICES REVIEW

An International Multidisciplinary Quarterly
Review of the Welfare of Young People
Editor: D. LINDSEY

Children and Youth Services Review is an interdisciplinary forum for
critical scholarship regarding service programs for children and youth.
The journal contains full-length articles, current research and policy
notes, and book reviews.

Free specimen copies available upon request.

THE ARTS
AND
PERSONAL GROWTH

Edited by

MALCOLM ROSS

University of Exeter

PERGAMON PRESS

OXFORD · NEW YORK · TORONTO · SYDNEY · FRANKFURT

U.K.	Pergamon Press Ltd., Headington Hill Hall, Oxford OX3 0BW, England
U.S.A.	Pergamon Press Inc., Maxwell House, Fairview Park, Elmsford, New York 10523, U.S.A.
CANADA	Pergamon Press Canada Lta
AUSTRALIA	Pergamon Press (Aust.) Pty. Ltd., P.O. Box 544, Potts Point, N.S.W. 2011, Australia
FEDERAL REPUBLIC OF GERMANY	Pergamon Press GmbH, Hammerweg 6, D-6242 Kronberg, Federal Republic of Germany
JAPAN	Pergamon Press Ltd., 8th Floor, Matsuoka Central Building, 1-7-1 Nishishinjuku, Shinjuku-ku, Tokyo 160, Japan
BRAZIL	Pergamon Editora Ltda., Rua Eça de Queiros, 346, CEP 04011, São Paulo, Brazil
PEOPLE'S REPUBLIC OF CHINA	Pergamon Press, Qianmen Hotel, Beijing, People's Republic of China

First edition 1980
Reprinted 1986

British Library Cataloguing in Publication Data
Personal Growth *(Conference), Somerset, 1979*
The arts and personal growth. - (Curriculum
issues in art education; vol. 1).
1. Arts - Study and teaching - Great Britain - Congresses
I. Title II. Ross, Malcolm III. University of Exeter
IV. Series
700'7.7'1041 NX343.A1 80-40260
ISBN 0-08-024714-8

Printed in Great Britain by A. Wheaton & Co. Ltd., Exeter

Contents

vi Contents

Introduction to the Series

MALCOLM ROSS

This series of books springs from a particular impulse: a
feeling that those of us active in the field of arts educa-
tion must redouble our efforts to ensure the greater effect-
iveness of our work.

The impulse is strong, the felt need a matter or urgency,
even emergency. It arose against a background of economic
cuts-back and ideological reactivism: the troubles beset-
ting our society were being identified not merely by the
politicians and economists but by the populace in general
with the alleged failure of the schools to produce suitably
trained personnel for the country's industrial and techno-
logical needs. With the judgment that we'd all been having
it too good (and on the cheap). And with the call to apply
the strictest, most utilitarian and cost-effective criteria
to an overall assessment of our society, the way it works,
the services it relies upon and the output it generates.
In such a climate we should expect the arts, arts education,
the life of feeling, intuitive knowing and the things of
the spirit all to be severely tested - and, as I write, the
evidence offers all too plain an endorsement.

But I should like to think that we might have launched this
project even in less searching times - for the impulse is
not merely a reflex act in self defence as it were. Behind
the decision regularly to publish a collection of papers
treating the arts in education not as separate subjects
but as a <u>single discipline</u> lies the conviction that it is
only through the recognition of their common educational
function (as distinct from their separate several identities
and processes) that the arts will ever come to play the
significant part in the education of everyone, young or old,

vii

artistically gifted or otherwise, that we confidently pro-
claim they should. It is because we feel that arts teach-
ers, artists and everyone involved in arts education wher-
ever and at whatever level they work must find common cause,
discover their common interest and express themselves as
far as possible in a common language, that this series has
been conceived. Our hope is that these books - and the
conferences from which, in large measure, they will derive
- will make a useful contribution to the establishing of
this sense of identity and towards the strengthening of the
individual teacher's hand in his efforts to create the
appropriate ground for his encounters with those whose
feeling lives he seeks to strengthen, enliven and enhance.

The following topics will be the subject of future issues:

1. Relevance and Responsibility: Arts Education in a
 Changing World
2. Contemporary Arts
3. Arts Education and the Social Context
4. Arts Education and Aesthetic Development.

Preface

The papers that comprise the present volume all derive
from the conference held at Dillington House in Somerset
from the 23rd to the 28th July 1979 under the auspices of
the University of Exeter with assistance from the Michael
Marks Charitable Trust. The theme "Personal Growth" pro-
vided rather a reference point to wide ranging talk and
discussion than an area to be focussed upon exclusively
throughout the week. It seemed appropriate to make a start
from this particular base since the initiative for both
the conference and this publication came from the Exeter
projects in arts education now generally identified with a
special concern for the expressive role of the arts in de-
veloping the intelligence of feeling. We did not, however,
wish to imply that this new venture was merely to provide
an outlet for a particular view of the purpose of arts
education - indeed the scope of the work at Exeter has it-
self recently broadened out somewhat. What seemed to be
needed was an initiative that would bring teachers, artists
and others interested in arts education together in a sit-
uation that would allow sustained, informed and critical
dialogue on topics of enduring interest and importance.

"Personal Growth" certainly figured a good deal during the
week, and most of the papers in this volume reflect that
central concern to some degree, some more than others.
But part of our purpose on this first occasion was to
identify themes for future occasions and our choice of
speakers was also determined by this consideration. I
think it would be fair to claim for the conference that it
achieved an unexpectedly high level of intellectual and
discursive involvement. The kind of involvement that

leaves one feeling both refreshed and disturbed. The sense
at the end of the week was of new steps to be taken, new
issues to be disentagled, new possibilities to be tried out
- rather a feeling of confidence that solid work might be
done than of euphoria that a good time had been had. (I
think a good time was had by many of us, and there was some
excellent practical work developed alongside the talking.)
But we established that we had come together to think and
to clear our heads in order to enlighten our actions - and
I am personally glad that such a development has seemed
worthwhile among teachers not usually characterised by a
relish for thinking and talking.

The success of the conference depended in very considerable
measure upon the personal and professional assistance I
received from Jann Blake, David Farnell, Anna Haynes, Victor
Heyfron, Ken Robinson and Keith Stubbs. To all of them and
to the staff at Dillington House and in particular to the
Director, Peter Epps, I would wish to record my sincere
thanks and appreciation. The papers of all the guest speak-
ers are gratefully published in this volume together with
post-conference material provided by David Spurling and Victor
Heyfron. Perhaps I should just add that although a session
on Assessment and National Monitoring did take place no
formal paper was delivered and so the issue is not touched
upon directly in this volume. It will, however, be a major
theme in the one to follow.

After the conference I received a number of interesting
letters and papers and I should like to conclude this intro-
duction by quoting something written by David Farnell:

> "Meanwhile, there are landmarks. I believe
> this 1979 Summer School at Dillington House
> was a landmark. Talk of going out into the
> highways and byways brings back to mind
> John Wesley et al. It might be more appro-
> priate to think of forty or so teachers
> returning to their schools and each direct-
> ly engaging the consciousness of half a
> dozen more teachers and three or four hun-
> dred young people. Looking at the problem
> of dissemination like that can transform a
> pessimistic sigh for a lost cause into an-
> other pocket of optimistic and faith-filled
> action.

We all share two tasks We arts teachers
must convince the arts teaching force of
its importance to generations of adults who
are still children in schools and we must
make accessible both an arts teaching
praxis and a suitable language for communi-
cating it. With these jobs underway, arts
teachers become their own task-force, and
all those perennial grouses about the arts'
lowly curricular status pale under the
strength of teachers' convictions.

An unexpected optimism creeps over me."

Contributors

PROFESSOR S. JOHN EGGLESTON, Head of Department of Education, Keele University.

MICHAEL GOLBY, Lecturer in Curriculum Studies at the University of Exeter

VICTOR HEYFRON, Principal Lecturer, Worcester College of Higher Education

JOHN LANE, Founder Director of the Beaford Centre: currently a trustee of the Dartington Hall Trust

HORACE LASHLEY, Senior Education Officer, Commission for Racial Equality. Editor CRE Education Journal

PROFESSOR LOUIS ARNAUD REID, Professor Emeritus of Philosophy of Education, University of London Institute of Education

MALCOLM ROSS, Lecturer in Education at the University of Exeter. Director of the Arts Curriculum Project at Exeter University.

PROFESSOR SIR ROY SHAW, Secretary General, Arts Council of Great Britain

DAVID SPURLING, Teacher of English and Drama at Wymondham College, Norfolk

Meaning in the Arts

LOUIS ARNAUD REID

The given title of this paper is short: the questions it
raises are many and complex. (A book I wrote with the same
title (Reid, 1969) could only touch on a few essentials.)
'Meaning' is a word of many meanings: Ogden and Richards
(1923) found sixteen, I think, and none of them (including
the shallow and very overworked term 'emotive') threw much
light on art. 'The arts', again, have I think for good
reasons a common name but they are so many and so differ-
ent. In literature one might ask 'What is the meaning of
(or how do we interpret) Tolstoi's treatment of Anna or
Levin; or the 'meaning' of <u>Hamlet</u> or <u>Lear</u>, or of a Shake-
sperean sonnet. But what about Whistler's <u>Nocturne</u>, or a
geometrical abstract by Mondrian, or Bach's 'great' G minor
organ fugue? (Stravinsky said, 'Music has no meaning'.)
What is the 'meaning' of a classical, or religious paint-
ing? Or of a dance without a 'programme'? And why 'a'
meaning? Is there not a plurality of valid interpretations?
These examples illustrate the varieties both of 'meaning'
and of the arts. Even the word 'in' in the title raises
questions. Is meaning 'in' the arts, or 'in' our minds?
Or should it be 'meaning(s) <u>of</u> the arts'?

This will not be a lecture on semantics. All the same we
shall have to try to get clear about some of the ambigui-
ties of meaning, and, later, about what 'art' tries to be
and do, in order to be surer of what we are, and are not,
discussing today.

The commonest use of 'meaning' (which may be called 'refer-
ential') is in words and sentences, where visual marks or
sounds and sequences of them are symbols whose meaning can
be found in a dictionary and/or through use in a context.

1

But things can mean (to our minds): clouds can 'mean' rain,
or spots scarlet fever. (This could be called a causal, or
symptomatic, use.) Then there is 'meaning' in a <u>personal</u>
sense. Things - e.g. a momento, or a picture or a piece of
music, can have a personal meaning or importance to me. Or
we can say of a person, 'his life seems to have no meaning,
no purpose or system.' It can seem "a tale told by an
idiot, ... <u>signifying</u> nothing". Acts, too, can 'mean':
'he's hurrying to catch the train'. And there is logical
meaning, of many kinds.

What is the relation (or non-relation) of these senses of
meaning to 'meaning' in the arts? Assuming for the present
that there is some sense in using this form of words (in
using 'meaning' here at all) the general answer is, I think,
that none of them, <u>in themselves</u>, will do - though some at
least may influence, or enter into art.

Mere referential meaning will not do. It enters into some
arts - word-using literature for instance; drama, some pic-
tures or sculptures: some dance may contain referential
elements. But the full meaningfulness of any work of art
is never found simply by referring to something else.
Again, a work may be 'symptomatic' of, say, a cultural tend-
ency, or it may have some particular personal meaning for
you or me; or there may be some logic in it. But none of
these differentiate artistic meaning.

So, if none of the various existing meanings are in them-
selves appropriate when we are trying to understand the
meaning of specifically artistic meaning, what do we do?
There is no conventionally agreed meaning of artistic 'mean-
ing': if so we shall have to try to discover our own - and
see whether it 'works'. This may seem a desparate remedy,
and a dangerous and difficult one, because, since there has
been, until recently, so little philosophical attention to
the particular and specific meaning of artistic meaning,
the other senses - specially the 'referential' and 'sympt-
omatic' and 'personal' senses - will from long habits in-
evitably obtrude, and any new 'meaning' is certain to be
confused with them.

John Hospers, in a book <u>Meaning and Truth in the Arts</u> pub-
lished in 1946, faced with the same problem, offered his
own definition of meaning in art as follows: - "A work of
art means to us whatever effects (not necessarily emotions)

it evokes in us ... whatever effects it does evoke consti-
tute its meaning for us. As we become more acquainted with
the work of art, the effects it evokes in us gradually
change, but in that sense its meaning for us (as I have de-
fined it) gradually changes too ... Its meaning may or may
not be describable in words - in most cases it is not,
since few if any states of mind (particularly affective
states) are describable to the satisfaction of the person
who experiences them. " (Hospers, 1946, p 75.) I believe
this definition - which Hospers admits to be arbitrary -
says something which is very true: but as it stands is too
subjective in emphasis - evocation of changing <u>effects</u> on
us, rather than on the work. A work of art does certainly
evoke effects in us, which change as we come to know it
better: but this does not differentiate art. For so does a
person we meet, and come to know better, or even the new
car which we buy and get to know better. Hospers however
goes on to say something rather different. The phrase, he
says, 'the meaning of a work of art' "is not concerned with
trying to answer the pseudo-question 'What does the work
mean?' but rather with the question of the relation of the
formal element in art to the expressive or content-element
- what has been described ... as 'life-values' " (Hospers,
1947, p 77). Here again is a significant statement of an
important aspect of art which sets difficult and complex
questions of the relation of form and content which any
philosopher of the aesthetics of art must face. They are
not questions I am going to discuss now as such (though
they are involved in what I shall be saying later). Nor am
I here concerned with criticism of Hospers' excellent book.
I want instead to offer my own account of artistic meaning
as far as possible in terms of the actual experience of
artistic meaning as it happens and exists.

Here is a provisional try. Very roughly, I think what I
mean when I talk of meaning in art is something like this.
When I apprehend a work of art which is worth attending to
- look at a picture, watch a play, read a poem, listen to
music, watch dance - and do so with all my attention, dis-
crimination, feeling, alive, I find that there is something
immediate, of intrinsic significance and importance there.
It is different in each work, and it is so <u>embodied</u> in what
I perceive as a unique and particular and individual thing
that I can never <u>say,</u> never translate exactly into terms
other than what is before me what the <u>meaning-embodied</u> is.
But I know that I find it there and nowhere else.

Your first reaction to this may well be that it is an eva-
sion, or a vicious circle. Instead of defining meaning in
a form of words, I am simply pointing to the very experi-
ence of meaning which we want to understand. In using a
term like 'intrinsic significance' it seems to beg the
question, since 'intrinsic significance' is just another
word for 'artistic meaning' **which we want to know** about. This
is true. There is a circle here. But it is not a vicious
circle, since I am deliberately saying that the meaning of
the <u>word</u>'meaning'here is only known through the <u>experience</u>
of what the referential word 'meaning' refers to. I am
saying that <u>no one can know, ever, what 'meaning' in art</u>
<u>means except by experiencing it, knowing it intuitively,</u> by
<u>having an actual, existent experience of art.</u> So what is
required now is a further analytic elucidation of the nat-
ure of artistic experience.

The term 'meaning-embodied', and particularly the hyphen
connecting the words 'meaning' and 'embodied' is absolutely
crucial to the <u>conceptual</u> understanding of artistic mean-
ing. (I am not here saying that no one can understand a
work of art <u>aesthetically</u> without understanding the con-
ceptual meaning of the word: artistic experience does not
entail philosophy.) 'Meaning-embodied' is a technical term
expressing something which is essential to aesthetics and
art as it is to nothing else. This is important. The word
'embodiment' is of course quite a common word, used in a
number of senses and contexts. You can say that I am try-
ing to 'embody' my thoughts about art in the words I am now
using, or that a committee embodies its decisions in a
written resolution. True enough. And the word 'express'
would do just as well. But the difference between 'embodi-
ment' used in other contexts and its special usage in art
is that in other usages the <u>medium</u> of expression or embodi-
ment has an external relation to its meaning, whilst in art
the medium in which meaning is expressed has an internal
relation to the meaning. Or, a little more precisely; in
ordinary usages of 'embodiment', the <u>form</u> of the medium
used - e.g. words - is instrumental to the understanding of
the meaning of the ideas which the words express, and one
attends to the form of the medium only in so far as the
ideas or concepts are understood clearly by means of the
medium of words. The form, e.g. the syntax of the sent-
ences used, is of course important. But the sounds of the
words or the rhythm of the sentences here do not matter:
the same thing, more or less, could be said in other words

or sentences, and in many languages. But in art all these
things matter crucially.

The best illustrative example is poetry. Poetry uses ord-
inary words, referential symbols, to indicate wide ranges
of meaning, and up to a point these meanings can be ex-
pressed in language used in the ordinary way. About kings,
for instance, it can be said that they wear crowns, that
they have had peculiarly difficult and dangerous problems
to cope with, have feared assination, are surrounded by
pomp. And they all die. The meaning of this is clear
enough. But read, in a way which shows how the meaning and
the impact of the felt <u>values</u> of the ideas and images is
achieved in the choice, the sound and rhythm of the <u>words</u>,
this:

 ... within the hollow crown
 That rounds the mortal temples of a king
 Keeps Death his court, and there the antick sits,
 Scoffing at his state and grinning at his pomp;
 Allowing him a breath, a little scene,
 To monarchise, be feared, and kill with looks,
 Infusing him with self and vain conceit
 As if this flesh which walls about our life
 Were brass impregnable; and humoured thus
 Comes at the last, and with a little pin
 Bores through his castle wall, and farewell king!

Here, the conceptual meanings are as conceptual, (as ana-
lysed), clearly distinguishable from the vivid pictorial
and other images, from the sound, the weight, the light-
ness, the rise and fall, the forward urges, the arrests and
pauses, the rhythms ... of the word - patterns. <u>Aesthetic-
ally</u>, as we read, or hear, the poem with an undivided
wholeness of appreciation, the two are simply aspects of a
single indivisible meaning, the poetic meaning. In actual
existing aesthetic experience of the poem, the two are in-
separable; and we do not try, in this same aesthetic ex-
perience, even to distinguish them analytically. This is
what I mean by 'meaning-embodied'.

You will notice that I use the word 'meaning-embodied' as
a single hyphenated word. I avoid here what might seem a
natural alternative: 'embodiment of meaning'. I do this
because that form of words suggests that there is <u>first</u> a
'meaning' (conceptual and imaginal), and <u>then</u> it is ex-
pressed or embodied suitably in a medium. Considering for

the moment the making or creation of art (rather than of
the presented, completed work) this is not what happens.

In the making or composition of any art the meaning (the
artistic meaning) comes into being, is created, or if you
like is gradually discovered, in the process of working in
a medium - whether it be words, paint, clay, stone, sounds
... I am not at all denying of course that there are, be-
fore a work is actually started, ideas, images, feelings,
emotions ... But in the process of making, or struggling
to make, out of these preliminary ongoings there emerges,
in the process of working with and forming the material, a
new thing, the artistic meaning. It is wrong, when think-
ing of meaning-aesthetically embodied, to suppose that
meaning is embodied in the same sense as when we 'embody' a
complex of ideas already reflected upon, in a particular
form of words - say the committee resolution. For there,
as has already been suggested, the same complex of ideas
could be expressed in other words or in a number of differ-
ent languages. It is the ideas here that matter; the sound
or shape or rhythm of the word-pattern does not matter - as
it matters crucially in artistic embodiment when words are
used. In poetry the shaped images, the sounds, shapes,
rhythms, etc., of the words, as we read them (preferably
aloud) are an essential, an organic, part of the poetic
meaning. The meaning-embodied is something directly pre-
sented to us: we are not referred away to something else.
The ideas and images, which can, if looked at analytically,
be called the referents of the words, are now aesthetically
united with them in the new creation.

I chose poetry because it clearly shows how the two dis-
tinguishable elements become united in aesthetic embodiment
in the poem which is presented to us, the presentation.
The arts are very various; but all works of art are presen-
tations. Painting and sculpture, music ... are presenta-
tions in which meaning is embodied. And the same kind of
thing happens as in poetry. In representative painting,
for instance - classical or religious, or landscape - the
subject-matter is selectively taken up by the artist,
thinking and feeling in terms of his medium, and trans-
formed into a new thing, the picture, where we see not the
subject-matter as such, or a pattern of shapes and colours
as such, but the new thing, made by the transforming hand
and mind of the artist, a new revelation, its embodied
meaning presented to us.

In the representative painting (or the poem, for that
matter), two aspects of the functioning of meaning can be
distinguished. One is its functioning as derived from ref-
erential meaning - the subject-matter of the representative
picture (or of the poem) - but transformed in art. This
has now been discussed. The other is meaning as function-
ing entirely within the completed work itself. Take
Cezanne's Le Lac D'Annecy. Its 'meaning' partly derives
from the fact of its subject matter, a particular lake, as
seen by Cezanne and transformed by his genius into the pic-
ture. But the other aspect of its 'meaning' is what vol-
umes of words, or statements of fact, could never convey,
and what is, rather inadequately, referred to as its per-
ceived form - in which is included the whole structure of
everything we have to see in order to know it: colour and
colour relations, lines and their direction and relation-
ships, shapes, volumes, etc., etc., an indescribable vari-
ety somehow making a single unity-on-variety, a many-in-
one.

The emphasis on these two aspects of aesthetic meaning
varies in different examples and in different works. In
poetry and representative visual art they are both clearly
present. In purely abstract visual art and in pure music
- neither of which is 'about' anything in life outside the
art - the 'meaning' of the art seems to arise from entirely
within it. (This 'seeming' is not in fact wholly valid:
the materials - shapes, colours ... sounds, rhythms, etc.,
have symbolic significance quite outside their use in art.)
In a Mondrain geometrical abstract, or a Ben Nicholson or
in some Kandinskys, one dwells within what one visibly
sees, with no thought of subject-matter meaning - though
Kandinsky did have some idea of certain colours and shapes
having symbolic meaning. So in a fugue, where the 'voices'
chase one another in a sort of flight, we dwell entirely
within the form of the flowing music.

It would be a mistake, however, to imagine that this is
just a kind of cold attention to 'form', without content,
and that we are only concerned with what has been called
(not altogether fortunately, I think) 'aesthetic surface'.
In art, there is no form without content, or content with-
out form, and in an abstract art like pure music it can be
a mistake even to say that the emphasis is on form rather
than content, because form and content are so completely
united. On the other hand in a representative art like

drama, it is obviously easier to point to the content as-
pect of a play as distinguished from the form - though it
is still only a distinction of aspect and never a separ-
ation.

What is implied by saying that the purest music - music
without words or programme, such as a Mozart sonata or a
Bach Fantasia and Fugue - has content as well as form is
(1) that though there is a purely factual basis for music -
the facts of tones, tensions between tones, intervals be-
tween tones, pitch, time, volume, tone-colour, texture -
these, when they become underlined elements in music are never just
mere facts; they are underlined values. It is impossible to enlarge
on this (as I do in four chapters in my book). Let me
simply say, over-simply, that we 'feel' them, and that they
move us in a great variety of ways. They are not cold
facts, cold materials coldly built up into a formal system,
but living elements created into the living system which is
the music. The structure of the system we call the 'form':
but it is the form of living elements which, as we experi-
ence them, vibrate and resonate, stirring sometimes a sense
of significance which can reach down to great depths of
human experience. And (2), this form of living elements in
a work is not, as we experience it, just a static struct-
ure. Music is a temporal form, and though the piece as
written in symbols on the pages has of course a sort of
static structure, as the music is played or as we listen to
it, the meaningfulness is developing until the last note,
and our growing realisation of the meaning with it. (With
visual abstract art, which of course as a given work is
static, the same exploratory growth of the understanding of
its internal intrinsic meaning is needed too - though the
description would have to be rather different.)

I have said a great deal about 'meaning'; and I have used
the word 'symbol' sometimes. If I say a little about
'symbols' now, I think it may throw some further light on
the notion of meaning-embodied.

The words 'symbol' and 'meaning' are correlative, at least
up to a point. The nature of a symbol is to 'have' (in
several senses) meaning. (I say 'up to a point' because it
might be arguable that there can be meaning without there
being a 'symbol'. But this, I think, is not relevant here.)
A symbol underlined means. And underlined what a symbol means is something
necessarily conceptually distinguishable from the symbol

itself. The most obvious case of this is the referential
word-symbol, where the noise or visual mark is distinguish-
able from the (e.g.) concept which it means. The sound or
sight of the word 'cat' is distinguishable from the concept
or idea of 'cat' - which in turn applies to any particular
cat.

The materials, becoming elements, out of which a work of
art is creatively made, are not referential symbols like
words (except in the special case of verbal arts, where
referential words are a part of a more complex process of
symbolisation). Sounds, intervals ..., colours, shapes...,
do not have defined, limited meanings to which they always
refer. And, whereas in a verbal statement or argument, the
meanings of the words have to stay more or less constant,
or there is confusion, ambiguity, contradiction, the 'mean-
ings' or sounds, intervals, colours, shapes ... are in art
constantly changing according to their aesthetic context
and relation to the whole particular and individual work.
This is true in poetry too, where words change their mean-
ing according to context. There is poetic punning, which
is not a joke, but part of the poetic ambiguity which is a
familiar feature of poetry.

This view of artistic symbolism is sharply opposed to any
view of some of what has been called 'symbolist' art.
Susanne Langer (1957) distinguished between the 'symbol in
art' and the 'art symbol'. In Bach's _Passions_, for instance,
there are certain recurring motifs intended to express
certain feelings and ideas: Kandinsky uses (e.g.) circles
or colours to stand for 'meaning'. These would be symbols
occurring _in_ art. But for Langer (and myself) it is the
whole work as experienced which is the art-symbol.

There is a problem here. If, as I have said, a symbol
means something "necessarily conceptually distinguishable
from the symbol itself", it follows that art-meaning is
distinguishable from the perceived work, and it would look
as though the meaning of the art-symbol were to be found
outside the work of art. If that were literally true, it
would contradict all that I have been trying to say about
meaning-embodied. But the formulation of the difficulty in
fact brings out the very essence of the difference between
what I may now call the 'embodiment-symbol', and all others.
Meaning is indeed conceptually distinguishable from the
symbol which means (and the perceived work from its

meaning) if we are speaking philosophically and analytic-
ally. But in art as actually experienced aesthetically,
where we are <u>not</u> thinking philosophically and analytically,
the meaning certainly is not separable, or even distinguish-
able, from the symbol, but, as we experience it thus, is
meaning-embodied, in the way unique to art. Art <u>draws</u> from
an unlimited source of meanings from life outside art, but
it takes them up into itself, transforms, transmutes, tran-
substantiates them and presents us with complex and utterly
irreducible and indivisible meaning-embodied. Another way
of expressing this is to say that we are directly presented
with art which is 'meaning<u>ful</u>'. (Reid, 1931).

The meanings from life outside from which art draws mean-
ings and transforms them, and the meaning-embodied in the
work itself, are <u>values</u>, or value-meanings. An over-simple
way of saying this is that, although values are related to
facts, it is never mere matter of fact, or the recording of
such fact, that the artist is concerned with, but facts (or
indeed anything) he <u>feels</u> about, and knows partly through
feeling. A proper account of this would take more space
than I have here. (It started with three papers written in
the 'twenties and in other writings since. E.g. "Towards
Realistic Psychology", <u>Journal of Philosophy</u>, (1924).) I
must content myself with making some bald dogmatic state-
ments.

(1) The <u>division</u> (not the conceptual distinction) between
(a) feeling and the rest of functioning mind as (b) think-
ing, knowing (or cognising), as (c) being actively inter-
ested (the 'conative' aspect), has been disastrous for the
understanding both of feeling and of knowing. It has even
been said that 'we no longer think when we feel, or feel
when we think'. Very misleading too has been the all-but-
universal habit of coupling feeling and emotion, speaking
of feeling-and-emotion in one breath. Feeling is the basic
notion; emotional feeling occurs sometimes when we are, in
a not exactly definable degree, stirred or churned up.
Emotion is occasional or episodic; but feeling is present
throughout conscious waking life, though for the most part
we do not notice it. (2) Feeling is an inseparable as-
pect of everything that happens throughout the whole of
human waking consciousness. It is immediate experience.
In a paper to the Aristotelian Society (1976) I said:
"Feeling is the inner side of conscious experience in the
widest and most usually accepted sense of that term,

conscious experience which in human beings includes bodily
sensations, actions of various kinds, thinking, imagining,
having moral and aesthetic experiences, maybe religious
ones, coming to know and coming to terms with the external
world, ourselves and other people ... Feeling is the im-
mediate experience of indwelling in that conscious life in
its most inclusive sense." (3) Feeling is not to be iden-
tified with hedonic tone, that is, with pleasure or un-
pleasure (as it has been in the **past**); but it often has
hedonic tone, is pleasurable or unpleasurable - though not
always. (4) Feeling, being what has just been described,
is not a separate 'faculty' of mind, but an aspect of con-
scious mind-and-body (or, if you like, of the psychophys-
ical organism) and is organic with all the rest. (5) And,
as thus organic, it shares in the transitive, or self-
transcending character of knowing (or cognising), and of
conation, the active side of mind, being out-goingly inter-
ested. This organic relation, particularly to cognition,
is of vital importance in the present context.

The meaning-embodied in art, I have suggested, is value-
meaning. Although in looking at a picture or listening to
music with great care, attention and discrimination, we are
perceiving a complexity of formed content, up to a point
(but never, never completely) describable in factual terms
- yet we are perceiving it in a feelingful way. We are
cognising it with intense feelingful interest; we are
apprehending it with what can fairly be called 'cognitive
feeling'. We are cognitively feeling, or feeling cogni-
tively, the art as yielding valuable meaning. Although it
is not an adequate account of value to say that values are
things-that-we-care-about, feel-about, it is certainly true
that feeling about things, at some stage, is a necessary
condition of knowing them at all as values. It is, for
instance, true of moral, as well as of art values. We may
have heard that integrity or consideration for others is
'good'; but if we have never felt, directly and intuitively,
their goodness, we do not truly know them.

The word 'cognition' is a cold word, and is mostly used to
mean knowledge-about facts, concepts, or knowledge involv-
ing logical reasoning. Because of this habit of mind, it
is often said that aesthetic knowledge is not 'cognitive'.
Of course there must be, for art to exist at all, much
knowledge of facts and concepts, in the ordinary sense of
'cognition', knowledge for instance of history, of

materials, techniques, etc. This does not exclude some
element of feeling, since feeling as immediate experience
is present throughout waking consciousness, as I have
suggested. But feeling does not, or does not necessarily,
play a noticeable part in knowledge-about-facts. There is
also, however, direct intuitive knowledge, knowledge-of:
and where it is knowledge of value-facts, of persons we
care about, of moral good, of art, then feeling does play a
quite essential part in the very knowing. In this knowledge
feeling is indispensably present from beginning to end: and
it is fused inseparably with cognition.

Considering the knowing of a work of art as given, feeling
works in several ways. (1) There is the (relatively)
passive, or what I call the 'affective' aspect of feeling.
(Many people use the word 'affect' to indicate the whole of
feeling, affect qualified by hedonic tone: I think affect
is only one aspect of feeling: the other aspects come from
its organic relations with conation and cognition: there is
what can fairly be called 'conative feeling'; and there is
'cognitive feeling'.) In the 'affective' aspect of feeling,
we feel, or are affected, more or less passively, by what
is given. The work is given, and we 'indwell' in what is
given. We relax, let it flow over. But (2) feeling has a
positive, active function; it reinforces (conative) inter-
est and sharpens attention. (3) Partly by doing this, it
illuminates what we cognitively see or hear. We may know
the notes, understand intellectually the structure of, say,
a piece of music as performer or listener; but unless we
discriminatingly feel the flow and progress of it directly
and intuitively, we are still mainly knowing about it in a
detached way. Without feeling it, without moving along
with it, feeling its flow and progress, we only half know
it as music. Feeling, analytically distinguishable from
cognition is, (I repeat) in the asesthetic experience it-
self utterly inseparable, even indistinguishable, from cog-
nition in the total thing which is knowing music musically.
The two become one. It is a knowing of meaning-embodied,
by a person, knowing holistically. The same is true,
mutatis mutandis, of the other arts.

In conclusion. This has not been a paper on art education
in schools - a field with a bewildering variety of aspects
- and of course not confined to the visual arts. (And I
think it is a pity that the term 'Art Department' is taken
to apply to the visual arts only: to have 'Arts Centres'

might be a more liberal idea.) If 'meaning-embodied' and
the 'embodiment-symbol' are of central importance, as I
think they are, then art educators ought to do what they
can, to make the experience of it real in the teaching of
art.

Two ways of doing this are familiar enough. One is the
making and working in various materials - which should be
open to everyone. The other is learning to appreciate with
discriminating enjoyment the works of artists past and pre-
sent. Either can be done effectively only by really good
teachers. On the practical side, they need to be themselves
artists understanding the imaginative use of materials and
techniques, knowing their pupils, and the right moment to
suggest and help, and when to leave alone, when to speak
and when to be silent: there are no rigid rules.

On the other hand there is the learning to discriminate and
enjoy with some aesthetic understanding. Very few school
children will become full-time artists. But there is the
whole long heritage of the arts, arts which have expressed,
and influenced, a wide range of cultures. This heritage is
open to all, if only they can learn to enter into it. Edu-
cation for this has been widely neglected in this country,
and many teachers of art have had no training in systematic
criticism. As one art teacher remarked: 'they do not know
how to proceed or what to say'. In the United States much
more attention has been given to the teaching in the class-
room of critical appreciation, of what Professor Harry
Broudy (1972) has happily named 'Enlightened Cherishing':
the pages of the American Journal of Aesthetic Education,
too little known in this country, bear witness to this.
Courses in 'art appreciation' are often held in contempt -
but I think more because of the way they have been taught
than anything else. If children are encouraged not just to
see pictures (for instance) and pass on to the next one -
as happens in a gallery - but to look at them, taking time
to look, notice, analyse, perhaps at a stage describe in
words some of the things they see, what they feel about
them, and then, after all this, make their own tentative,
uninhibited and honest evaluations, isn't this a valuable
beginning? Should not verdicts, judgments, come at the end,
not at the beginning? And if this is done, in relaxed
groups, and with an informed, tactful and sympathetic tea-
cher, isn't this something which may open up an infinitely
rich field of potential experience which they can go on

enjoying all their lives? The value of group discussions
is that different individuals see and value different
things, and so, in a receptive atmosphere, learn to notice
and see more and more in any art object intrinsically worth
this attention.

I have, in this paper, talked exclusively of the arts,
leaving out the enjoyment of nature. But the habit of sen-
sitively looking, listening, contemplatively enjoying the
beauties of the natural world in the most direct and immed-
iate way - and, in an open ambience which the enclosed work
of art does not usually possess - is a source of ineffable
joy. The aesthetic, in one way, is wider than art, as art
in its own way is wider than the aesthetic. Despite the
unfortunate associations of the word 'aesthetic', I think
that 'aesthetic education' is a more liberal description
than 'art' education'.

Aesthetic education is different from other 'subjects' in
the curriculum - history, geography, economics, mathemat-
ics, the sciences - in that whilst their symbolisms are,
broadly speaking, referential, the embodiment-symbol is not.
The other subjects are - again broadly speaking - concerned
with concepts and matters of fact, and the symbols which
elucidate these express the concepts of the matters of fact
and are put in symbolic languages through which we under-
stand the concepts and facts. But the symbol of art is
presentational: we know art not through symbols that refer
to anything else, but by direct cognitively felt acquaint-
ance with meaning: meaning-embodied. This is a way of
knowing which, though it may have its analogues (in know-
ledge of persons, for instance) is unique. And anyone who
has no experience of this way of knowing, has missed out on
a major factor of his education as a human being.

REFERENCES

Broudy, Harry S. (1972) Enlightened Cherishing. University
 of Illinois Press.

Hospers, John (1946) Meaning and Truth in the Arts.
 University of North Carolina Press.

Langer, Susanne. (1957) Problems of Art. London,
 Routledge and Kegan Paul.

Ogden, R.K. and Richards, I.A. (1923) The Meaning of
 Meaning. London, Routledge and Kegan Paul.

Reid, Louis Arnaud. (1931) A Study in Aesthetics. London,
 Allen and Unwin.

Reid, Louis Arnaud. (1969) Meaning in the Arts. London,
 Allen and Unwin.

Reid, Louis Arnaud. (1976) Feeling, Thinking, Knowing,
 Proceedings of the Aristotelian Society, 1976-7, Vol.
 LXXVII, 165-182.

The Responsive School

MICHAEL GOLBY

In this lecture I shall attempt to articulate a view of the
school curriculum to encompass both the social and the pol-
itical setting for curriculum development. I shall try to
address some issues in Arts education but from the view-
point of a generalist and an interested outsider rather
than from that of an initiate. I shall try to present a
number of questions I think to be central to responsible
curriculum development, arising from a general analysis of
the setting for change. It will be for you as specialists
in the relevant curriculum areas to take up the detail of
these questions, and indeed to modify the questions them-
selves as you see fit.

The main propositions I shall be elaborating are as follows

(1) Schools are best understood as 'forms of life'
 or 'cultures'

(2) The founding tradition for mass secular
 schooling has bequeathed curricular emphases
 on academic knowledge and high art, emphases
 which are at best unproven in our experience
 to date

(3) Schools are both local and national institu-
 tions, but they have been more responsive to
 centralised forces than to local contexts.
 The time has come to reappraise this situation

(4) There is a crisis in the schools, which may be
 characterised as <u>either</u> failing to do the <u>old</u>
 things properly <u>or</u> as not having found the

16

<u>right</u> things to do

(5) How to define the problem is the greater part
 of the problem; what is lacking is an adequate
 conceptual model of schooling within which to
 define our dilemmas. I shall be using the
 first outline of a possible model to suggest a
 few, inevitably oversimple, questions for arts
 educators

(6) Approaches to curiculum development heretofore
 have been marked by successive waves of mixed
 utopianism, careerism and simple-mindedness
 resulting in the martyred integrity of the
 change agent and the despair of the righteous.
 To all this, the teacher has been very largely
 a bemused, and quite often an amused, observ-
 er. I shall conclude what I have to say with
 a few remarks on prospects for change in
 schools based on a view of schools and teach-
 ers as neither obstreperous reactionaries nor
 as inert simpletons (not that is, as "prob-
 lems" for the innovator) but as underpowered
 mediators at the centre of deep and serious
 social and political conflicts.

Schools as 'Forms of Life' or 'Cultures'

Like hospitals, sports clubs, communes and families,
schools exhibit their individual atmospheres; they espouse
their own rituals; they teach their own myths; they trade
in their own currency; they enjoin on their members their
own codes of behaviour and belief; they maintain their own
authority structures and their own forms of inter-personal
negotiations. In short, its distinctive view of the world,
its prevailing values, attitudes, beliefs and rituals, and
its revered artefacts constitute the culture of a human
group. Two important additional points need to be made
here, however, to bring these generalisations closer to the
reality. Firstly, few human groups and particularly insti-
tutionalised groups, exist <u>in a steady state</u> without con-
tention, rebellion, dissent and other such conditions for
growth and change. We nearly always find alternatives ex-
isting alongside the dominant culture; sometimes these al-
ternatives aspire to challenge the dominant culture, some-

times they co-exist as sub-cultures within a climate of
mutual toleration and sometimes they survive in a framework
of uneasy suspicion just short of conflict.

Secondly, human groups(and institutionalised groups in
particular) very seldom exist _in isolation from one anoth-
er._ Messages and meanings, attitudes and values, rituals
and responses are transmitted from one to another through a
whole range of complex processes, including notably the
exchange of personnel, ideological debate and competition
for resources.

These ideas are extremely general, but I think they have to
be to provide the scope we need to cover the ground before
us. An illustration at the macroscopic level may help.
Britain today may be said to exhibit a culture in the sense
of the way of life that an American author describes when
he claims we have come to terms with post-industrial con-
ditions more realistically than the apparently more suc-
cessful West Germans. We have become less wedded to ma-
terial expectations, we value leisure etc. But within the
society there are diverse attitudes towards materialistic
achievements. There are those like me who will simply
light another candle when the lights go out and those who
will deplore the descent of Britain into an apathetic, in-
efficient and ungovernable morass. People holding both
views will be united, quite possibly, in a general belief
in the democratic process; they will share a number of un-
derstandings of our history and, above all, they will share
a view of the world conditioned at root by their shared use
of the English language. What Wittgenstein called the
'agreement in judgements' that makes communication possible
in a shared language is balanced by substantial disagree-
ment in specific spheres. At a certain point, the point
where the language ceases to be of use, a society falls
apart because the culture to which the society is host has
fragmented into warring sub-cultures. And it is precisely
in anticipation of this sort of breakdown that education is
necessary (as opposed to desirable or advantageious) to the
continuance of a society. To put the point directly, how
does a multi-cultural society hang together if it is not by
some kind of universally comprehended consensus of overall
values?

In this picture, crazed as it is, what seems minimally
clear to me is that tradition plays a central part. It

sustains a concept of membership at national, local, insti-
tutional and familial levels and it funds our basic under-
standings of our predicaments as citizens, employees, mem-
bers of social groups and classes, as families, etc. It
fuels our opinions and aligns us with those of like mind
whether as teachers, scholars, artists or whatever.

Coming to the school level, it should be clear that the
culture of the school and the many sub-cultures it embraces
is not a purely idiosyncratic local phenomenon; a phenomen-
on to be ascribed to a few influential persons perhaps.
No; schools are astonishingly alike in many ways and one
can readily see the same dramas played out upon many a
staff room stage. So, too, the perennial causes repeat
themselves; to integrate or not to integrate (thus chal-
lenging subject identity); to stream or not to stream (thus
perhaps challenging notions of egalitarianism and social
co-operation as a vision for school). These causes are
causes precisely because they are the points of departure
between values and viewpoints held deeply within the life-
worlds of definable groups within the educational process.

Schools, then, do not present a monolithic picture but are
riven with contending views. But then so too is the sur-
rounding society. For I have been talking so far as if it
were only the teachers, the professionals,who were to count
in school culture. There are, however, those others - the
students themselves. And it is astonishing how readily we
avoid their presence. I attended a meeting of the assoc-
iation of 'friends' of a comprehensive school recently;
there was heated debate whether the students could be ad-
mitted to membership. Worse, their claim was lost. Thus
the students are to remain recipients of compulsory charity
from their betters, a tradition of very long standing in
public affairs and particularly in education, social wel-
fare and health.

In a comprehensive school we must expect the whole range of
values to be exhibited; whether we then celebrate the fact
is a question I shall come to. But it is an unavoidable
fact. A fact that came home to me one lunch-time sitting
on a school field the other day when I was talking to a
very clever 13 year old about ontology; not twenty yards
away a gaggle of his peers were involved in a petting
session behind the boiler house.

<u>My first proposition</u> then is that the school curriculum is
a selection from the culture (to use Denis Lawton's phrase,
which has the only disadvantage of implying a rather more
deliberative and rational process than is the case). Cur-
riculum emerges from the fundamental ideologies of those
holding the power to decide, manipulate and influence.
Curriculum has not yet resolved the problem of relating to
the whole spectrum of outside cultures - cultures repre-
sented from within by the students it caters for.

<u>My second proposition</u> is that the dominant tradition in
schooling has emphasised "high-status" knowledge of the
bookish or academic variety ('knowing that' rather than
'knowing how'). 'High status' knowledge is implicated here
tautologically, because the dominant tradition derives from
an education reserved for an elite. Where the arts are con-
cerned the emphasis is on high culture; education is seen
as a preparation for a life of, at best, appreciation and
patronage of the fine arts; there is a celebration of the
classical excellences and the form of beauty. All this at
the expense of personal competence and self-expression.
this dominant tradition, then, finds its apothesis in the
great public schools and their imitators the Grammar
schools. So it is that the comprehensive school in its in-
fancy has to appeal to the only working model of secondary
education available and take over a whole network of prac-
tices, assumptions and values whose applicability to the
new scene has come into increasing doubt as the comprehen-
sive movement has developed.

What this founding tradition has urged upon the schools,
however, has been a stablising uniformity of curriculum
which while perhaps not ultimately defensible in all its
aspects, has nevertheless provided a common starting point
for all schools. The first cracks in the edifice of same-
ness in the curriculum can perhaps be timed in 1951 with
the breakdown of matriculation and the development of indi-
vidualised programmes at O and A levels. Perhaps other
landmarks can be located; the development of CSE, especial-
ly at model three for example; certainly, however, we are
now at a juncture where the truth of my <u>third proposition</u>
may be the more readily discerned.

Schools are national institutions promoting cosmopolitan,
even universal values, but they are also unmistakeably
local institutions, serving communities having their own

distinctive flavour and containing their own cultures.
England and Wales today is characterised by its national
system of education, locally administered and pervaded by a
very high degree of devolution of decision making into and
within the schools. Though this statement is not true
without qualification - for example, it is perhaps mainly
power over methods that rests in classrooms while financial
power, the power to provide the wherewithal, is retained
well away from the workplace, nevertheless there is an im-
portant implication in the observation. The individuality
of schools is expressed principally through style, personal
relationships and teaching methods rather than through cur-
ricular aims and content. The responsiveness of schools to
their clientele is thus restricted to its means rather than
its ends. The time is coming, I believe, for this state of
affairs to be called in question. The evidence for this is
everywhere at hand; the consumer movement, political devo-
lution, regionalism and the civil rights and ecology move-
ments in their various ways contribute towards this sense
that the power of the centre must be tailored to the needs
of the periphery. Most recently, Michael Young (1979) at
the Advisory Centre for Education has demonstrated that two
out of three people in Hackney want alternative schools
provided within the comprehensive system. Vocational
schools, free schools, basic skill schools and religious
schools were the categories gaining assent from more than
20 per cent, while for performing arts schools a respect-
able 8 per cent could be found. Says Young (1979) "The
extent of diversity in the comprehensive system is not
apparently nearly as much as people would like". Signifi-
cantly for my theme, and perhaps ominously, "fewer people
of British stock wanted an alternative school than did
people from other ethnic groups". (Young, 1979).

There are, of course, ways of accommodating to such demands
and a great deal has been done in New York City in the way
of responding to cultural diversity with mini-schools,
specialised high schools, alternative high schools, voca-
tional high schools, 'schools without walls' and the like
(Golby, 1979).

But to respond without deeper reflection would be, philo-
sophically, to commit the naturalistic fallacy - a desire
does not entail its legitimacy; socially, it would be to
invite the fragmentation of a society into uncommunicating
ghettos; and politically to dissolve the state. These may

be desirable ends, but they are not lightly to be embarked upon.

Let us therefore review the situation. The school is poised between, on the one hand, 'vertical' ('cosmopolitan', 'national' or 'central') forces purveying in the main the dominant tradition and on the other hand horizontal forces expressed in the culture of its clientele. I owe this three-dimensional way of formulating the case to Stuart Hall (1978). The "interests" of students, for example, in so far as they are pursued in school and not merely used as motivational impulses, represent the horizontal impact of part of the community culture, for students' interests are not personal idiosyncrasies. They are culturally funded. Curriculum development on this analysis is a matter of striking a balance between the claims of the centre and the interests of the locality, where these conflict. Among the more obvious central forces are DES, the quasi-autonomous HMI, Schools Council, examination boards, universities, CBI and TUC. Among the more obvious local forces are PTAs, local press, local politicians, organised minority groups, the individual parent and the student himself. That both these groups are themselves riven by lines of stress and dispute in no way invalidates the observation that what I have called 'central' forces almost inevitably press for uniformity of curriculum and comparability of standards (witness the centrality of the protected core curriculum issue in the so-called Great Debate, which was in reality little more than a political road-show). 'Local' forces, by contrast, are more inclined to press for more responsiveness to local contingencies.

In any case, teachers are left holding the baby. They are also likely to retain in some measure some part of the balance of power - and the more contention there is the more obviously so. It is at this point that the uneasy mid-cultural position of teachers presents itself. Teachers, as William Taylor (1969) observed, occupy an ambiguous position as guardians and gatekeepers for a social and cultural elite of which they have never been full members.

That is my review of the situation. Whether to reassert the value of the old order or to strike out and redress the balance in favour of something new? If the truth of my <u>fourth proposition</u> is accepted, that there <u>is</u> a crisis in the schools as represented in truancy, truancy in the mind,

apathy, and time-serving by both teachers and taught, what
to do? Optimists, like Jerome Bruner will declare we have
failed to keep what we teach up-to-date and call for renew-
ed pedagogy. Reformers, like Eric Midwinter, will call for
the abandonment of the traditional curriculum in favour of
politicised local awareness. The socialist stance to all
this is deeply interesting. Idealists like Tawney (admit-
tedly well before his time) and meritocrats like Wilson
will call for grammar school opportunities for all. Per-
haps that's just what we've got. Egalitarians like Raymond
Williams and Maurice Holt will call for a common curriculum
based on a common culture. The difficulty here is what is
the common culture; more pertinently, what ought to be the
common culture?

The problem is as I described it in my fifth proposition.
How to define the problem?

I shall move now to suggest some questions for arts educat-
ors arising from the application of my horizontal/vertical
model.

(1) What balance is desirable between appreciation
and criticism of the arts on the one hand and
expression and creativity on the other?

(2) To what picture of the role of the arts in the
cultural life of the citizen does the answer
to this question point?

(3) Are there stocks of artistic experience
whether in the comtemplative or expressive
dimension that should be available to all
pupils?

(4) Is there a basic minimum artistic literacy or
competence that all pupils should have as
participants in a national culture?

(5) What is the appropriate stance for schools to
take towards the popular arts; cinema, radio,
tv, pop, disco-dancing?

Should the school be intervening, in any way,
to analyse or develop these art forms?

(6) What is the appropriate attitude towards the
 art forms of distinctive sub-cultural, or
 other-cultural groups?

 Has the school an interpretive role here, as
 host to a variety of cultural forms in a
 pluralistic society?

(7) Are we willing to see the arts in the service
 of other educational objectives, for art to
 enter the fraught arena between the local and
 the cosmopolitan, Shakespear or street thea-
 tre? Shakespeare and street theatre?
 Shakespeare in the streets?

These questions are probably ill-formed. They suffer from
the boldness and generality of the curriculum model I em-
ploy and from my personal ignorance of the arts education
world. However, they may prove a start.

My sixth and final proposition concerns curriculum develop-
ment.

Curriculum development on my analysis is best seen as nego-
tiation over time between discernible groups holding vary-
ing views of what the school should be doing. In such a
perspective the following are crucial points;

(a) curriculum development is never a once-for-all pro-
 cess, completed with the production of a project,
 handbook or materials; neither can an evaluation ever
 be final, since all evaluation is conducted against
 the evaluator's educational values, which are seldom
 unquestionable;

(b) teachers are not 'rational consumers' open to success-
 ful argumentation from impartial intelligence gather-
 ers; rather they are key figures in the curriculum
 negotiation process, possessing their own viewpoints
 and values;

(c) teachers therefore require, in their role of curric-
 ulum developers, to obtain special skills of value-
 classification and analysis, both of their own educa-
 tional values and of others;

cf.

anal

analy

(d) teachers also need to develop the ability to 'manage'
 prolonged controversy, accepting that only from debate
 can progress derive, yet teaching day by day according
 to the criteria available to them.

(e) The school as an organisation must play its part in
 enabling staff to meet these challenges by relinquish-
 ing its traditional bureaucratic management, redundant
 ritual and class boundaries, internal and external.

For these tasks the schools and their staffs are at present
severly underpowered. Possible sources of assistance are
the advisory services, in-service training and education,
and consultancy. Of these the emerging forms of school-
based INSET and consultancy holds out better prospects than
the traditional LEA adviser. The adviser is inevitably im-
plicated in the authority structure of the employer and
wields some power in resource allocation, promotion for
teachers etc. Non-school-based INSET has too often proven
a recipe for irrelevance and a forum for the further myst-
ification of the practitioner by the theorist.

School-based INSET and consultancy have as their chief gen-
eral aim the fostering of the school's capacity to make
judgements on its own performance and to take more consid-
ered curriculum decisions. Only as a self-monitoring in-
stitution can a school ever locate its position relative to
'central' and 'local' pressures, upon it. 'Situational an-
alysis' is only possible through a fuller engagement with
the school's cultural and social environment.

In the foregoing, I have tried, not wholly successfully, to
withhold my own value position. In the interests of some
analytic clarity, I have attempted to stand back from the
scene a little. I would do you little credit, however, if
I felt I had caused you to believe I have no real concern
for the directions of change. My small convictions, never-
theless, are over-matched by my massive uncertanties. The
model I have presented seems to me to embrace those uncert-
anties and allow us to ponder them. Over the next, say
ten, years will schools grow increasingly alike or unalike
one another? In what ways will the interpersonal relation-
ships made possible by the schools develop? How will the
locality of the school be reflected in its curriculum? How
will the schools compromise between their functions as
trainers and selectors for a shrinking job market, and

their mission as cultural mediators? These large questions
defy prognostication. They behove us to keep a cool head.
Certainty in these matters is not available and the desire
for wholesale solutions can only be counterproductive.

REFERENCES

Golby, M. (1979) New York City: some curriculum issues, in
 Proceedings of the Exeter Society for Curriculum Studies
 Vol. No. 1.

Hall, Stuart. (1978) Education and the Crisis of the Urban
 School, in Raynor, J. and Harris, E., Schooling in the
 City. Ward Lock.

Taylor, W (1969) Society and the Education of Teachers,
 Part 3. Faber and Faber.

Young, M. (1979) Greater Parental Choice in the Compre-
 hensive System. Advisory Centre for Education.

Arts Education, the Curriculum and the Multi-Cultural Society

HORACE LASHLEY

In this paper I wish to argue that ethnic minorities have brought with them valid cultures. Some aspects of these cultures are thousands of years old and have stood the test of time. They have repulsed many severe attacks from other cultures which were imposed on them through different waves of colonisation. Within these cultures are art forms which ought not to be ignored since their influence in the past has helped to rejuvenate and revitalise European Arts forms and more recently have treated the bases of communality on which can be constructed some form of "true" universal art form. The school has been much too slow so far to seize this unique opportunity of incorporating within the arts curriculum the arts of ethnic minorities. This process of ignoring can only occur to the detriment of a fully relevant and representative schools arts curriculum.

It is now widely accepted that culturally we are no longer working towards the "melting pot" solution to multi-cultural/multi-ethnic problems in society. The concept of a cultural mosaic is considered to be the more acceptable aim of such societies. Within the mosaic concept all cultures are to have equal currency and status. In Britain we tend not to talk so much of the mosaic concept as of "pluralism". The concept of cultural pluralism is synonymous with that of the cultural mosaic concept. The latter term has been popularised by the American. The former term has been the popularly used in Britain.

In Notting Hill, Manchester, Leeds and Bradford the West Indian community there have for many years organised an annual Caribbean carnival. Notting Hill in particular is a

27

major centre for this annual event which in many ways has
revitalised an otherwise dull, grossly impoverished phys-
ical and social environment. Leicester, Birmingham, parts
of London and Lancashire regularly have Asian weddings and
religious festivals which portray totally different yet
attractive and colourful cultural festivals and ceremonies.
The Chinese in Soho have for many years had an annual par-
ade which goes through the streets of the area. In all of
these activities significant numbers of the host community
participate. These numbers are increasing all the time as
is the level of participation. No longer do the local
white population just stand and stare. They join in. This
is particularly evident at the Notting Hill carnival.

Another major change which has taken place in high streets
everywhere in Britain is the opening of restaurants which
provide multi-cultural cuisines that Britain was not pre-
viously accustomed to. These changes are fundamental.
They are many facetted and their effects are socially
multi-directional. However, the major effect of these
changes so far appears to be more evident in the inner city
areas. In the schools of such areas the classrooms have
become multi-racial. Many of these major cities have had
their accustomed cultural variations very nearly transform-
ed. This has given rise to comments by older white resi-
dents that some of their areas have changed beyond recogni-
tion within their own life time. It is now a common sight
to see ladies in brightly coloured and magnificently em-
broidered saris and men in turbans. Kafkans have become a
commonly worn garment. Dashikis are no longer purely a
symbol of black consciousness. They are now an accepted
part of the fashion of both blacks and whites. Brian Jack-
son (1979) describes a Huddersfield scene when he visited
an immigrant home. In his description he refers aptly to
the colour and other visual stimulus that he found striking
and a useful contribution to what was otherwise a drab en-
vironment.

In 1970 the D.E.S. Statistics in Education (HMSO, Volume 1)
indicated that immigrant pupils formed 3.2% of the school
population in England and Wales with critical concentra-
tions of over 20% in a number of Local Authorities. Har-
ingey had 26.5%, Brent 26.9%, Ealing 20.3% and ILEA 18%.
Within individual schools in these and other LEAs as much
as 50% and more were from immigrant background. There were
individual schools with "critical" concentrations of over

90%.

For many years now a number of teachers have been concerned
about the ignorance of their schools of the cultures of
ethnic minority pupils. They have also been concerned
about the possible harm that this ignorance may have on the
educational experience of such pupils. Marina Maxwell
(1968) writing in Race Today drew attention to the way in
which the school system ignored the culture that black
children brought into the British school. Townsend and
Brittan (1972) pointed out the need for the school to re-
flect in its curriculum the multi-cultural/multi racial
composition of the school.

The Arts education curriculum has been unduly corsetted by
prevailing definitions and interpretation as to what is
art. The inhibitative restrictions which have resulted is
a creation of the dominant class and its exclusivist value
system. This has for centuries now determined "what is
art" and "what is culture". It has also determined the
criteria and definitions as to what is acceptable "civil-
ised art" and "primitive art". It has tended to exclusi-
vise art and the practice of art to the point of making art
the sole "property" of a small number of selective individ-
uals who are classified as artists, writers, poets, drama-
tists and those who support art are classified as patrons.
Art appreciation has in the process become an expression of
"high culture". Only the "educated man" has the powers of
determining the criteria of art appreciation and interpret-
ation.

In order to become an artist therefore one has to be in-
itiated into the mores and values and life-style of that
exclusive group considered to be artists or patrons of the
arts. The use of the school as a pool of selection for
artists has operated under the constraint of the exclusi-
vist perception of Art. The mass of "ordinary" school
children are fully aware of this framework within which we
define and conceptualise Art. They are consequently quite
clearly able to assess that whether or not they become art-
ists has more to do with their social class situation than
their potential artistic ability. Schools have become vic-
tim of the "high culture" definition of the Arts.

This exclusivist attitude to the arts has been used to cat-

egorise and classify the arts of other countries. In the
case of most non-white countries their Arts have tended to
be designated as "primitive art"; art forms which allegedly
had not in any way contributed to the development of West-
ern European culture. In spite of this it is universally
accepted that, as Van Loon (1938) says, "Art is as old as
the human race and it is just as much part of man as are
his eyes or his ears or his hunger or his thirst". He goes
on to say "we have never, as far as I know, come across a
race (no matter how far it happened to be removed from the
centre of civilisation) that was completely without some
form of artistic expression". However this so-called open
acceptance to a universal declaration of Art has not pre-
cluded Van Loon and others from separating Arts into ac-
ceptable and unacceptable forms based entirely on the per-
ception of "racial worth".

Fuseli in a lecture to the Royal Academic in 1885 said,
"Greece is the legitimate parent of Art". To this day
there has not been any dramatic move away from Fuseli's
conception of the origin of the arts as we know and accept
them as "pure art".

In recent years there have been a series of exhibitions
mounted by the Museum of Mankind and other museums. These
exhibitions have significantly questioned the myth of the
supremacy of European Arts. These exhibitions have high-
lighted various art treasured and works of importance many
of them created many thousands of years ago, very often
long before similarly sophisticated art forms had evolved
in Europe. In spite of this, these exhibitions are pre-
sented as anthropological exercises and not purely as Art
exhibitions. There is therefore an overtone of ethno-
graphic curiosity and not straightforward Art visualisation
and appreciation as used in viewing the works of Michael
Angelo or Picasso or Rodin. Similarly other Arts such as
music, dance and drama of non-white cultures have been
treated more as a curiosity than as matter for serious art
appreciation. To further reinforce this attitude to the
Arts of non-whites is the fact that exhibitions of their
works, traditional as well as of more recent origin have
tended to be held not in Art Galleries but in Anthropol-
ogical museums.

Within British society the significant ethnographic changes

that have taken place have brought with them different art
forms as well as different cultures. Many of these newly
introduced art forms have survived intact and have conse-
quently avoided the instability, upheaval and short life
which has been the experience of most western art forms and
movements. These art forms have retained the natural live-
liness, movement and colour that one finds in many of the
countries from which they have originated. They have been
uninhibited by the restrictions of social control.

Art schools have done a disservice to our changing society
by not readily responding to societal changes. On such oc-
casions that art students have been seen doing practical
work in the community, their subjects are invariably the
reproducing of architectural still life: civic buildings,
churches and the like. I have seldom, if ever, seen such
students capturing the vivid movement, life and colour in a
multi-racial market place or reproducing embellished saried
Asian women and vivacious West Indian youth. The fact that
we live in a multi-racial society is of no significance to
the curriculum of the art schools. The fact that society
has changed and is changing and that the artist is as much
a generator of change as a recorder appears to have little
significance to the policy makers in arts education and in
art colleges. The fact that community art is now a thriv-
ing activity appears to be of no significance to institu-
tionalised art education. These are facts which must be
taken account of by the arts education institutions and by
the people who influence arts education. Picasso (1972)
grappled with this very same situation of the artist and
the social power that he possesses when he rhetorically
asked, "What do you think an artist is? An imbecile who
only has eyes if he is a painter, ears if he is a muscian,
or a lyre in every chamber of his heart if he is a poet, or
even if he is a boxer only, some muscles?" He answered his
own question thus: "Quite the contrary, he is at the same
time a political being constantly alert to the horrifying,
passionate or pleasing events of the world, shaping himself
completely in their image."

One of the perplexing questions that has never failed to be
asked is whether art is the property of the people or the
people the property of art. Katherine Kuhn (1965) says
"art is related to men's beliefs and disbeliefs, to his af-
firmations and negations, what and how men 'believe and
disbelieve' is mirrored in the art of times". However, the

exclusivisation of the arts has resulted in the separation
of art from the people. In spite of this situation the
arts are of concern to all. Stendhal (1971) has argued that
"the arts follow civilisation and spring from all its cust-
oms even the most baroque and ridiculous". We have a natur-
al endowment to a sense of aesthetics. Even in the most so-
called socially deprived of homes you find trinkets, cheap
masks, reproduced art and artefacts. The result of the ex-
clusivisation of the arts has resulted in the development of
so-called "popular", "inferior", "vulgar" and "commercial"
art forms. These are totally separate from the school sit-
uation, condemned by high culture and ridiculed by the dom-
inant ruling class. These forms of the arts, available for
popular mass consumption, separate and allegedly reflect
social-class derived aesthetic values. As educationists and
as members of the educated middle-classes we deem them to be
vulgar and devoid of worth. As teachers we are responsible
for this social dicotomy since we have not made the arts
education curriculum sufficiently relevant to the lives of
the children we teach nor have we attempted to remove the
high culture ethos that has pervaded arts education. Arts
education in schools has thus created a situation of alien-
ation from aesthetic experience rather than enhancing young
people's arts discriminations and aesthetic involvements.

Schools dispense education on their own terms. In so doing
they very often hinder curriculum development and innovation
by discriminating against influences from the children's en-
vironment. In Arts education in particular this disservice
has been particularly pronounced. The art forms of non-
Europeans have especially suffered from this attitude of
education. Arts education in particular has suffered. Out-
side the school environment many of these art forms have
been given a seal of "tolerant" approval rather than any
serious acceptance of equality on terms with European art
forms. This is supported by the fact that the criteria used
for judging the merits of such works of Art do not fall
within the criteria for judging European Arts.

The retinue of rituals which the ethnic minorities have
brought, also has its own technologies and crafts which have
been used to sustain them. Folk art and craft have devel-
oped from the ritualistic performances of the vast majority
of traditional cultures. The rituals which have been prac-
tised have resulted in the development of particular forms
of instruments as well as implements concerned with the

exercise of the cultural rites. Special forms of music and
dance have been devised. Particular songs are sung and in-
struments played. Many of these rituals are concerned with
fertility, harvesting, life, death, birth, worship and a
host of other aspects of man's interaction with his natural
environment and preservation of life.

In the homes of many ethnic minority youngsters there are
artefacts concerned with their cultural rituals. The
school can benefit from this experience that ethnic minor-
ity children are constantly experiencing in the process of
maintaining their culture. The school can also benefit
from the atmosphere of artistic stimulation that they are
enveloped in in their home lives, the performance of their
religious rituals, the festivals they celebrate, be it
marriage, christening or coming of age. The artistic stim-
ulation these youngsters are exposed to spans a wide spect-
rum of activities, from paintings, sculptures, and other
artefacts, through music and dialect poetry. Taking this
to its very extreme Paul Kene Douglas recently described
West Indian life when he appeared on Black Londoners, as
one of theatre in its natural form. Consequently in the
composition of his poems he uses real life situations as
well as conservational language.

The school has failed so far to capitalise to the full from
the enormity and diversity of cultural and artistic expe-
rience that ethnic minority children bring into British
classrooms. If the school continues to fail to utilise
this experience not only will the school be poorer for this
failure but eventually the ethnic minority groups them-
selves who will have lost for ever a culture of their very
own. The homes of ethnic minorities are endeavouring how-
ever to keep their traditional culture alive. Their comm-
unities as well are also very active in doing so. If this
continues as an activity totally separate from the school,
yet again, we will be giving rise to the value dichotomy
between home and school. We have been made aware of the
consequences by numerous researchers as well as educational
writers (Milner 1975). However, in an attempt to preserve
the culture and the "native" artistry of ethnic minorities
the school must play a leading role. In doing so the
school will show that in valuing what the children have
brought in to the school system it values the children
themselves.

The Arts that ethnic minorities have brought with them are
part of their very own ethno-cultural self expression and
their self image. The curriculum of the school which has
continued to ignore as well as to exclude these art forms
has been responsible for the development of a poor self-
image of many ethnic minority pupils. The extent of this
poor self-image reflection accorded by the school is likely
to interfere in the learning experience of the child.
(Clark 1963). The extent to which this happens is related
closely to the organisation of the family unit which can
buffer the dominant cultural attack waged by the school
system. Thus the extended and very close knit Asian family
has been able so far to preserve a greater degree of "cult-
ural purity" than has been the case with the West Indian.

The West Indian youngster is developing new cultural patt-
erns based on the more traditional aspects of his African
cultural ancestry. He is developing a totally new culture
form based on the Rastafarian ideal; the belief that mother
Africa was the cradle of mankind. This cultural movement
has brought with it new arts forms which can be illustrated
in the works of young artists like Jah Leggs, and the
Jamaican artist Ras Hartman, Reggae music producing musi-
cians of the quality of Bob Marley and Peter Tosch and a
host of Rastafarian poets and playwrights.

The British Rastafarian movement in the main consists of
young blacks. This movement has developed without the
assistance of adult black West Indians who migrated from
the Caribbean. The Rastafarian arts forms although not
accepted by the school system, have been tolerated in many
of the inner city schools where youngsters of West Indian
background have been battling to preserve as well as to
create vestiges of cultural self identity. They are battl-
ing against a school ethos that is irrelevant to their ex-
perience as well as their culture. The school has refused
to accept their music, their dance, their drama, their dia-
lect and their very selves. This has resulted in these
youngsters turning into themselves searching for a cultural
identity, for a self presentation that will confuse and ex-
clude the school and its teachers. They consider it an
achievement to present the school system with a culture
that it will not easily understand or analyse. This they
consider to be a buffer from the dominant cultural attack
of the school and education which they perceive as an org-
anised overt activity. To the Rastafarian it is a buffer

that gives self-respect of a kind and privacy. What we have
come to call the West Indian child is a rather precarious
being. He has not hailed from a culturally homogeneous
background. However by our own design the West Indian has
now emerged. He has emerged from the very fact that British
racism has pushed black youngsters of a West Indian back-
ground to formulate their own dialects, music and tradition.
They have not maintained these cultural variations but
have a common West Indian culture based entirely on the
Jamaican experience.

The school must act as an incubator "hatching" new arts
forms for a multi-cultural society as well as preserving ex-
isting ones. It is expected that schools will form a focal
point for catalysing the various art forms that children can
introduce within the school so that the school can fuse them
into some new art form that is relevant to the British ex-
perience of all children in particular black British chil-
dren. The school should also act at the same time to retain
art forms of ethnic minorities that have been tried and
tested for centuries. The school therefore has a number of
important functions to serve which if properly carried out
will not merely preserve the identity of ethnic minorities
but will also help in the process of improving race rela-
tions, as well as giving more opportunity to potential art-
ists from ethnic minorities. In addition it will also expand
the arts knowledge of all pupils within schools and the wid-
er community in general.

REFERENCES

Clarke, Kenneth B. (1963) Prejudice and Your Child. Beacon
 Press Inc.

Coard, Bernard. (1972) How the West Indian Child is Made
 ESN in the British School System. New Beacon.

Jackson, Brian. (1979) Starting School. Crom Helm.

Kuh, Katherine. (1965) Break-up; the Core of Modern Art.
 New York Graphic Society.

Maxwell, Marina. (1968) Violence in the Toilets. Race
 Today.

Milner, David. (1975) Children and Race. Penquin Books.

Picasso, Pablo. (1972) Picasso on Art: A Selection of
 Views edited by Dore Ashton. Thames and Hudson.

Stendhal (1971) in Hemings, F.W.J. Culture and Society
 in France 1848-1898. Batsford.

Townsend, H.E.R. and Brittan, Elaine. (1972) Organisation
 in Multi-Cultural Schools. N.F.E.R.

Van Loon, H. (1938) The Arts of Mankind. George Harrap.

The Road from Wigan Pier?

JOHN LANE

On the nineth of June in the year 1311 Duccio's enormous
painting of the Virgin, or Maesta, completed after three
years work, was carried in triumph through the streets of
Siena to its place on the High Altar of the Cathedral. An
eye witness account describes this great occasion in the
life of the city:

> The shops were shut; and the Bishop bade
> that a goodly and devout company of priests
> and friars should go in solemn procession,
> accompanied by the Signori Nove and all the
> officers of the Commune and all the people;
> all the most worthy followed close upon the
> picture, according to their degree, with
> lights burning in their hands; and then be-
> hind them came the women and children with
> their great devotion. And they accompanied
> the said picture as far as the Duomo, making
> procession around the Campo as is the custom,
> all the bells sounding joyously for the de-
> votion of so noble a picture as this. And
> all that day they offered up prayers, with
> great alms to the poor, praying God and his
> Mother, who is our advocate, that He may
> defend us in His infinite mercy from all
> adversity and evil, and that He may keep us
> from the hands of traitors and the enemies
> of Siena.

Living in our own time, children of our own bleak, secular,
epoch, it is difficult to realise the extent to which the
arts once permeated the lives of common people. The Middle

or Gothic Age, when the Duccio was painted, was such an age
- for the West the last truly religious period. It was
this age, not considered as a political-economic system or
as a social hierarchy, but as a time when the mind achieved
a harmony and feeling of relatedness, that believed without
question in the value of art and participated imaginatively
in its making. We know, for example, that in the building
of the Gothic cathedrals - Chartres is the most familiar
example - whole villages moved to be nearer the work, and
men were prepared to learn subsidiary crafts in order to
help the professional masons. The procession which carried
the Maesta to its destination, to the sound of bells and the
singing of a Te Deum, was by no means unique.

No less common was the involvement of the mediaeval artisan
with his work. However they were by our standards filthy
and impoverished (or is it our own vanity which likes to
believe this?) our illiterate ancestors were also, as Coom-
araswamy (1943) would say "special kinds of artist". Their
work was their pleasure, their pleasure another kind of
work. There was then, of course, no word for art in the
sense of our "fine art" - art was all that was pleasing to
the sight - but in that (as in other religious periods) the
aesthetic and practical were one, their labour was a respon-
sible and qualitative skill. It was, indeed, as its beauty
still testifies, a kind of prayer, a kind of sacrament:
"the outward and visible sign of an inward and spiritual
grace". Even Duccio, the painter of (according to a con-
temporary) "the most beautiful picture that was ever seen
or made" was a purveyor of necessary goods: a local crafts-
man. He reflected the vision of a whole people, made the
invisible visible, spoke as (1919) said "to the
multitude and the few alike", but was in the most profound
sense a representative, a servant of the collective.

The same unity of culture, the same unity of art and life,
has characterised every society where the centre of gravity
has been, not economics, but religion. We do not have to
travel to the ends of the earth nor return many millenia in
time (though it should be remembered that one of the earl-
iest traces of human work are the cave paintings of Lascaux,
made some 30,000 years ago) to discover peoples for whom
what we now regard as 'art' were enhancements of the pro-
cesses of every day living. Look, for example, at the rich
blankets of the Navajo Indians or the masks of the Sepik

River region, the farm carts of Gloucestershire or the un-
paralleled quality of Korean <u>hakeme</u>: possessions which, be-
cause they expressed something in the being of the maker,
his tribe and its traditions, were supremely satisfying to
those who made and enjoyed them. Or listen to the dateless
words, close to prayer, of the Eskimos or the drum patterns
of the Africans, the excited singing at a Berber wedding or
the quieter words of folk-verse; verse which always seems
to draw upon a fund of imagery which belongs not to the
mind of a single poet but to the hidden emotional life of a
whole people. Such belong to a realm where ugliness does
not exist. Such are but the dialects of one and the same
language of the spirit. In image, symbol, myth and icon
that stir those associations, those overtones of meaning,
that enrich and deepen the experience of the senses by
speaking also to other levels of our being, man has always
expressed his illimitable sense of play and creativeness.
'Art', indeed, has always been for every normal society as
necessary to the spirit of man as food and drink to his
body: the normal means of identification, anamnesis and
orientation. Has always been so, that is, until we come to
our own time.

Why, then has it come about that in comparison with less
'developed' societies who live or lived in a way we should
consider beggarly, modern "progressive" societies have so
little regard for art? In answer to this question Herbert
Read (1969) has suggested that the change came about as s
consequence of the sudden increase in the size of societies,
a development that accompanies the industrialisation of a
country. It has certainly always been a matter for wonder
that the greatest epochs of art - Athens in the seventh and
sixth century B.C., Western Europe in the twelfth and thir-
teenth centuries, the city-states of Italy in the fourteenth
and fifteenth - are associated with communities which in
comparison with the typical modern state, were miniscule.
But although I believe that size and quality are closely
related, the cause, it seems to me, is quite other; lies,
in fact, in the gradual ascendency of the materialist phil-
osophy in the European mind. I refer, of course, to the
prevailing Western view of the world which was first artic-
ulated during the Renaissance and found its political
expression from the period of the Enlightenment. It became
the basis for government and the sciences and could be de-
fined as rationalistic humanism or humanistic autonomy.

The development of the mechanistic paradigm was perhaps
historically inevitable. The Middle Ages had come to a
natural end. It was exhausted, becoming an intolerable
despotic repression of man's physical being in favour of
his spiritual nature. In reaction, as Solzhenitsyn (1970)
has pointed out "we turned our backs upon the Spirit and
embraced all that is material with excessive and unwarrant-
ed zeal".

The new way of thinking, the new moulding of reality by the
technological imperative, which has been at the root, at
the very basic of human consciousness in the past three
centuries, did not admit of any higher task than the at-
tainment of happiness on earth. Everything other than phy-
sical well-being and the accumulation of material goods,
all other human requirements and characteristics of a subt-
ler and higher nature, were neglected by state and social
systems, as if human life had no other purpose than comfort.

At first, of course, the disregard of the immaterial had
relatively little effect upon the arts. It is true that
the new order of capitalism and absolution proclaimed the
Artist (like the soul in the Cartesian system) as set apart;
no longer a purveyor of goods which every one needed and
which could be ordered like any other material goods, but
an individual - eventually a demi-God - facing a public.

In keeping with the new-found delight in individuality, the
Renaissance also unleashed a bewildering pandemonium of
self-expression far removed from the impersonal ego-less
imaginative expression of the patterns in Islamic tiles or
the beauty of Gregorian chant. But these changes, dazzling
in possibility, seemed altogether good; a liberation of the
artist from the thraldom of mediaeval life. Two hundred
years ago it would have seemed incomprehensible that beauty,
once omnipresent would slowly wither and disappear from the
earth; that the arts would be confined as irrelevant lux-
uries to galleries and concert halls; that music, painting
and poetry should be largely concerned with remote formal
problems only comprehensible to a small circle of cogno-
scente.

Nonetheless it was to be. In this new world - at least by
the eighteenth century - the divinity of art was soon to be
reduced to decoration and entertainment. In the elegant
drawing rooms and palaces, composers even of the genius of

Haydn and Mozart created music for the diversion of a priv-
ileged minority. Literature, still important, was yet en-
tirely public; painting was outward too. A little later,
as we move into the nineteenth century, the age of Roman-
ticism, poets and artists, in reaction against the prevail-
ing atrophy of spirit had been forced even further from the
centre of the stage; forced to retreat into their own pri-
vate worlds; the wastes of subjective caprice. The twenti-
eth century artist, liberated of all social responsibility,
is certainly free to explore, invent, criticize and warn;
but free to the point of absurdity, "of icy loneliness" as
Ernst Fisher (1963) says. Holderlin, a poet contemporary
with Beethoven, mourning for his loss of function, raised
the despairing cry "What are poets for in a barren age?"
'Arts for Arts sake', a protest against the vulgar utili-
tarianism, the growing hell of what Munford (1934) has
called the "insensate industrial town", was the only reply.
The Post-Renaissance will to dominate, to control events,
to eliminate chance and the irrational, to make the self -
or soul - distinct from and superior to matter, present in
every field since the Renaissance - the political, social,
economic, moral, military and scientific - also pervades
our thinking, practice and values about art even when it is
in reaction to the prevailing ideology.

In the 1880's Neitzche announced the death of God. It was
as if this signified not just the subjugation of the crea-
tive spirit but symptoms of a more general decline in the
life of feeling which had nourished the rich cultures of
the past. For just as theology lost credibility in the
fifteenth and sixteenth centuries so did the inner world,
the world of meaning, in the nineteenth and twentieth.
Looking back at the recent history of our civilization it
is obvious that Galileo, Newton and Descartes, as they
built the philosophical framework of the next three hun-
dred years, had no notion that their distinction between
the external and the internal, between objective and sub-
jective, between the mathematically describable (and thus
knowable) and the irreducible, inaccessible, unmeasurable,
was not only false, but pernicious. Their philosophy was,
in truth, the road to Wigan Pier - the road to utilitarian-
ism, economic justification, means as ends, the inhuman
degradation of the human being in an industrial system
whose ugliness, as D.H. Lawrence (1928) described in "Lady
Chatterley's Lover" is its most dismal but ubiquitious
characteristic.

"The car ploughed up hill through the long
sqalid straggle of Tevershall, the black-
ened brick dwellings, the black slate roofs
glistening their sharp edges, the mud black
with coal dust, the pavements black and
wet. It was as if dismalness had soaked
through everything.

The utter negation of natural beauty, the
utter negation of the gladness of life, the
utter absence of the instinct for shapely
beauty which every bird and beast has, the
utter death of the human intuitive faculty
was appalling. The stacks of soap in the
grocers' shops, the rhubarb and lemons in
the greengrocers'! the awful hats in the
milliners! all went by ugly, ugly, ugly,
followed by the plaster-and-gilt horror of
the cinema with its wet picture annouce-
ments, "A Woman's Love"! and the new big
primitive chapel, primitive enough in its
stark brick and big panes of greenish and
raspberry glass in the windows Just
beyond were the new school buildings, ex-
pensive pink brick, gravelled playground
inside iron railings, all very imposing,
and mixing the suggestion of a chapel and
a prison. Standard five girls were having
a singing lesson, just finishing the la-me-
do-la exercises and beginning a "sweet
children's song". Anything more unlike a
song, spontaneous song, would be impossible
to imagine: a strange bawling yell that
followed the out-line of a tune. It was
not like savages, savages have subtle rhy-
thms. It was not like animals; animals
mean something when they yell. It was like
nothing on earth, and it was called sing-
ing. Connie sat and listened with her
heart in her boots, as Field was filling
petrol. What could possibly become of such
people, a people in whom the living intuit-
ive faculty was dead as nails and only
queer mechanical yells and uncanny will-
power remained."

It is this culture that now replaces that total experience
of an inherited tradition that the artist and poet, David
Jones, called the mythus; something rooted in all the ways
of feeling and living and doing and being that belongs to
the ancient cultures; the cultures that begin at home. The
culture that produced the Duccio Maesta and the Navajo rug.
The culture that western commercial imperialism has now all
but expunged.

It was the poet Schiller who remarked that our evident pow-
er and abundant rewards had been bought at the price of
what he called "the disenchantment of the world" - the dri-
ving out of the magic of things; the slow, inexorable, dry-
ing out of ancient springs. In fact many of the features
of contemporary society come from the fact that we have di-
vorced ourselves from our own deep, warm, instinctive life
and have come to despise and repress it with deadly ruth-
lessness. We see this manifested everywhere no less in the
pervasive ugliness of our industrial system which denies
the 'operator' an individual responsibility not only for
what he does but for the kind and the quality of whatever
he makes than in our empty churches and over-crowded cities
built in the image of an ideology which puts money values
first. The signs of the death of spirit are multiplying.
Yet, at this uneasy hour when loss of the delicate magic of
life seems most complete, a growing number of people, for
whom the narrowing of consciousness now falls within the
compass of their daily life, are beginning to be aware that
the price of finding oneself in this world has been that of
losing the world in oneself. Starved and empty they are
questioning the disappearance of the mysterious, rich and
encompassing symbol; the sacramental vision; the intimate
communion between being and being; the natural reverence
for life which the first man took for granted in himself.
They are questioning the rational, extraverted assumptions
of an atheist and mechanistic rationalism. A deep and per-
vasive crisis of faith begins as more and more people,
spontaneously withdrawing their support, undermine estab-
lished institutions. If the world has not come to its end,
it has certainly approached a major turning point in hist-
ory, equal in importance to the turn from the Middle Ages
to the Renaissance.

The error of the West has been the debasement, the muti-
lation, of the inner life. Is it therefore surprising that
the desire for more direct communion with inner realities

is now widely felt? It is in these depths that man must
seek the powers than can rescue him. Escaping from the
meagre reality of the workaday world the majority already
find some solace for their craving for transcendental ex-
perience through rock music, drugs, travel or sex, all
symptoms of an acutely felt imbalance in our society. Oth-
ers, making contact with the earth, with animals or other
natural forms are rediscovering their own reality immanent
in nature. Yet because people need to create a world more
real than workaday existence, a world eternal and indes-
tructible, it is to the inward journey that many are re-
turning like nomads travelling through the desert in search
of an oasis of cool waters and palms. So, today, various
strands seem to be converging - from Ecology, from Eastern
and Western mysticism, from Jung and the christianity of
Teilhard de Chardin - to create the possibility of a new
height of vision, a new level of life where our physical
nature will not be cursed as in the Middle Ages, but even
more importantly, our spiritual being will not be trampled
upon as in the modern era.

The most active element of this new spirituality is its
concern to extend, to refine, the perceptions of conscious-
ness; a transformation in our understanding of experience
in which the arts, with their power to re-awaken imagina-
tive vision, could play a central role.

Looking back at man's entire spiritual and cultural history
it can be seen that the arts (even if they were not named
as such) have always been an instrument for the perfecti-
bility of man, a primary means of transcendence, of what,
in the Far East, is called 'enlightenment'. That, after
all, is the quintessence of the artists' position: he is
there to call up the lost memory of our divine reality, to
reveal icons of that lost perfection for which the soul as-
pires and recreate in the flesh all experience lived by
other men, so that each man can make his own.

In our secular age it is still true that religion is most
alive only in the form of art. So in the future, as we
strive to expand consciousness, is it not therefore poss-
ible that the arts will take a more central role and the
artist - the seer, with his magical and sacramental vision;
his child-like joy in the life of the senses; his capacity
to dream - for the first time since the Renaissance will be
once more at once with society? It is the artist - the

dramatist, the musician, the painter, the dancer, the poet,
and those poets of the religious sphere we call saints -
who can call forth the new forms, new symbols, new icon-
ography on which a new society can be built. It is the
artist, who can give expression to the yet uncreated myth
of the new age. The time may soon come when the artists
will again be employed to set up altars to the mysterious
gods of life.

Yet, in the true spirit of this age, already emerging,
there will be no spiritual caste system as there is in our
own day, dividing men into workmen (whose activities are
denied the name of art) and artists (concerned with a sep-
arate and specialised activity). The new paradigm already
points to another form of society, a society where produc-
tion and need, beauty and function, work and pleasure,
would no longer be disassociated but reconciled. There is
indeed evidence that, on the one hand, the shorter working
week, and on the other, the compelling search for a quality
of meaning in what we do, has already produced a revival of
interest in activities which gives play to the creative
faculty. With the development of new technologies and
shorter working hours we are bound to see a massive resurg-
ence of self-actualising craft work for individual and home
production. A society can only be considered truly civil-
ised when it is possible for every man to earn his living
by the very work he would rather be doing than anything
else in the world. It is to be hoped that both the enjoy-
ment of work for its own sake and the synthesis of the in-
ner man and the environment he makes, will be dominant
features of the future.

But that is the beginning of a new story, the story of the
gradual re-birth of man, the story of his gradual regener-
ation, of his gradual passing from one world to another, of
his acquaintance with a new and hitherto unknown reality.
The words are Dostoyevsky's; the last paragraph of _Crime
and Punishment_ which traces the great spiritual change
which takes place in the mind and heart of its hero.

Like other artists I have already quoted - Schiller,
Holderlin, Solzhenitsyn - Dostoyevsky had also sensed the
dereliction of the Western spirit, the need for change and
suffering. I like to think that the inner transformation
of his lone hero anticipates the heart-change in many more,
an imminent sea-change in our entire civilisation.

"Otherwise" as D.H. Lawrence (1968) foresaw some fifty years ago "we shall be in for a great debacle."

REFERENCES

Coomaraswamy, A.K. (1943) 'What is the use of art anyway?' from Why Exhibit Works of Art? New York, Luzac & Co.Ltd.

Fisher, E. (1963) The Necessity of Art. London, Pelican.

Lawrence, D.H. (1968) Return to Bestwood, Phoenix II.

Lawrence, D.H. (1928) Lady Chatterly's Lover. London, Heinemann.

Mumford, L. (1934) Technics & Civilization. London, George Routledge & Sons Ltd.

Read, H. (1969) Art & Society from The Arts & Man. Unesco.

Solzhenitsyn, A. (1970) One Word of Truth, The Nobel Speech. London, The Bodley Head.

Yeats, W.B. (1919) The Cutting of an Agate. London, Macmillan.

Art Process and Product

DAVID SPURLING

It seemed to me at the time (the afternoon of Monday 23rd
July 1979) and I have not since wanted to change my view,
that many of the threads of the first part of the course,
"The Creative Arts in Education", led in the direction of a
single, over-riding distinction, namely, the need for us to
restate our sense of the relationship between art as activ-
ity and art as object, between process and product. For
the moment, I would not like to refine the idea any further,
for a more refined statement draws on material in the en-
counters we have had with John Lane, Michael Golby and
Horace Lashley. Yet the debate is located in an epistemol-
ogy of the arts which is relevant to the concerns of all
educationalists, not merely those whose special concern is
the arts.

First "The Road From Wigan Pier". John Lane's paper reflects
a deeply-felt view of the state of our society. Anyone who
commits to paper a statement of urgent feeling in these
scientific days runs a considerable risk and the expression
of this view is an act of magnanimity in that it risks the
kind of exposure which rational materialism is quick to de-
ride. Further, in making the paper available before coming
to talk to us, John Lane deprived himself of the protection
which might have been afforded to him by surprise. I very
much admire the magnanimity and generosity in the circum-
stances of the paper's presentation. Nevertheless, I do not
share its views, and it would be wrong to allow feelings of
admiration to stifle convictions which I believe I hold with
equal urgency.

The double-edged quality of personal conviction has direct
bearing on the creative arts. For the moment, however, I am

more concerned with our thoughts and imaginations than the
forms they body forth. Without conviction we cannot prop-
erly (if thinking is being) be said to think anything in
the fullest sense. If what we say does not put our selves
on the line it is a disintegrated form of utterance. Yet,
once we have conviction, we harbour a dangerous monster
cavorting among the pastures, selecting the delicacies
which satisfy its own passions and ignoring the commons of
the rest of the world. It is powerful, but not always
critical: it entertains evidence which can be used to
shape thoughts to corroborate its position. By contrast,
however, with the freedom from creed and openness which
should characterise an empirical approach, conviction runs
the danger of becoming a closed rational system, parasitic-
ally feeding on its own mystery.

I want to take issue with three aspects of "The Road From
Wigan Pier": its view of the past; its attitude to the in-
fluence of "the mysterious, rich and encompassing symbol";
and its view of modern spirituality The past, as present-
ed in that paper, sets three standards which we cannot hope
to meet. First, it is sweetness and light whereas the pre-
sent is darkness and confusion; second, its great artefacts
comprise a tradition against which the efforts of artists
of our own time seem puny; third, whereas the past seems to
reflect a stable theocracy, our age reflects only chaotic
self-interest, presided over by a pernicious materialism
signalling the death of God.

Time, like space, confers on objects an exoticism. They
become valuable in large part simply because they are not
objects of our own culture. Yet if we place the objects
into what we might reasonably suppose to be their cultural
background, their charm becomes somewhat tarnished. The
Davey lamp, for example, has a more massive and substantial
quality than the more tinsel objects of our own culture
developed against the background of rising prices of metals;
it seems better (if not more lovingly) made. It was devel-
oped - and perhaps this is the technical expression of love
- to diminish the number of mining disasters. It can now
be found in shops selling bric-a-brac, an exotic object,
divorced from the realities that gave rise to it.

But Davey lamps are a far cry from Navajo blankets and
Gloucestershire carts. To explore their nature, to feel
my way into the objects themselves, I would like to make a

space/time switch. Recently I have had more experience of
collecting objects made exotic by space than by time. I do
not possess a Navajo Indian blanket, but, while working in
Cameroon, I took the opportunity to buy several blankets
made (I am told) in the Sokoto area of Nigeria. They are
prized for their home-woven qualities and the rich colours
of their natural dyes. Each blanket is made of six narrow
strips sewn together and then embroidered in traditional
patterns. Like others who acquire exotic objects, I was
trying to blaze a trail (or mark out my personal territory)
in a world that is always threatening to turn me into a
creature of mass pressures.

My motives are related to the weavers and dyers of the
blankets and the drawers of the water that washed them, but
the working out of the relationship is uncertain. I must
confess that my view of those blanket makers is very shad-
owy, for I never saw them. There was a go-between. Itin-
erant Hausa vendors (travelling salesmen, if you like) are
a feature of Yaounde, as they are of many African cities.
To arrive at their markets many of them travel long dist-
ances in bush taxis - an expensive and sometimes dangerous
business. This no doubt affects the price of their goods.
The asking price of the blankets I am referring to might
start at about 25,000 francs (say £50). The seller would,
however, happily settle for 12,000 and might be persuaded
to accept 10,000. What the original blanket-makers got for
their labours doesn't bear thinking about; people age young
in African villages. I imagine a spare existence and toil
poorly rewarded.

What about Gloucestershire carts and medieval cathedrals?
- we had better not think of abbeys By what analogies can
we find our way into their making? One of the difficulties
facing modern school-leavers (I do not digress) is the
switch from school, where they are encouraged to develop
satisfying activities, to work, where they are expected to
do as they are told - to carry out a task located specific-
ally within someone else's conception. In these circum-
stances the young are trained to very precise requirements
by their elders who show them exactly what to do, as far as
this lies in their ability and patience, and curse them
when their work doesn't come up to scratch. Through a mod-
el of this kind, I find it difficult to see much reward in
the work of a wheelwright. Getting spokes into hubs at the

right angle is an exacting task requiring repetitive pre-
cision. From comparison with current practice in the
trades the chances are that the tasks of the men who made
carts were specialised and that they already reflected the
repetitive and partial tasks that seem to us such an odious
feature of modern factory practice. Putting a spoke into a
hub is a different thing from conceptualising a cart. Hav-
ing and seeing the whole thing as one are surely the pre-
rogative of possession.

Recently I have gained much benefit from the instruction I
have received from my neighbour who is a builder (once self
-employed, now working for the council). Working on exten-
sions to my house I have had to learn how to glaze, render,
plaster, set a window-frame, hang a door and so on. But
professionals do not do this. They have specialists -
joiners, plasterers, tilers, glaziers - who do the jobs
more efficiently by virtue of their particular expertise.
Inside the trades there are further specialisations.
Joiners hanging doors might split the work - one puts in
the linings while the second does the actual hanging. In
what remains of the crafts these evidences of specialisation
look very much like the analytical approach to the factory
process, embraced, not as an imposition, but as the best
way of doing a job. Making my house, I can conceive the
whole; owning a cart I would see its beauty the better for
its not being used, but the joys are joys of possession,
not of making.

Similarly with cathedrals: I find it difficult to believe
that the labour that went into their creation was all vol-
untary and joyful. Our local parish church is thatched -
something you don't see from the inside when you are using
it. To repair the ridge will cost thousands of pounds and
we are few in number, our annual collections totalling
perhaps £1,000. There clearly are people who find a signi-
ficant role in helping with such activities, but most of us
are already busy people: where will we find the time to
help? Will I ever be able to render the porch? - another
task to be done. We are told that a village grew up around
Chartres cathedral. In my experience people move to find
work when moving is less unpleasant than staying put. It
costs money to move. When I have moved it has often been
with the sense of growing liabilities. One of the reasons
that made me keen to go to Cameroon was the prospect of a
limited period when I might keep my head above water

financially. Now, as a scale III teacher, if I have to
sell house to move for promotion, it will take years for me
to break even. The notion of moving to work simply for the
praise of God, or because that is the work I want to do,
would be an extravagant luxury almost beyond my dreams, at
any rate, a very unlikely opportunity. Artefacts are the
end-products of complex social processes; to understand
them fully we must try to enter into these processes.

A second aspect of the treatment of the past in "The Road
From Wigan Pier" is its curiously selective approach to
cultural movements. The thought of Galileo and Descartes
may be harbinger of a bleak world of humanistic autonomy,
but what about the alternatives? Perhaps the inquisition
may have foreseen something of the effects of the heresies
it feared, but few would attempt on those grounds to vind-
icate its harrassment of Galileo. Surely "alternatives" is
the key word. The course of history is not an irrevocable
tapestry which records the effects of conflicts and tensions
now concluded. We live, like all past ages, in the midst
of our own dialectic. Their conflicts feed ours. Take,
for example, Locke's two treatises on civil government. On
the one hand, since they assert the need to find some human
rationale as the basis of government, they may be thought
to be essentially humanist in inspiration. The first of
them certainly sets out to refute the ideas of Sir Robert
Filmer because his ideas were grounded on theory derived
from the Book of Genesis and consequently in large part
non-negotiable. Locke's work, like Galileo's, sought to
release thought from constriction. If they have, in a
sense, been the cause of a decline in spirituality, the
decline is an interpretation of our age, not necessarily
the age itself, and, in so far as such work derives from
legitimate enquiry and a search for freedom, any spirit-
uality that is based on the notion that it would have been
better if it had not existed is arid and false. True
spirituality is a response to the conflicting pressures of
an age, not a blanket to smother them.

The work of the Romantics, like that of Galileo, can be
regarded as deviation from the norm in that they rejected
the implied authorities of a theistic system, but even if
the expression "the wastes of subjective caprice" can apply
to Romantic painting, where some of the posturing may seem
empty, it is wholly inappropriate to literature. Here

individual imagining was restructuring the world; it was
not concerned with caprice. Even Shelley (1962), who was
sent down from Oxford for his pamphlet "The Necessity of
Atheism", could speak of poetry as "a thing divine" and
poets as "the hierophants of an unapprehended inspiration";
Wordsworth in the Tintern Abbey Ode seeing "into the life
of things", was no more indulging in caprice than was
Coleridge (1965) in describing the imagination as a force
which "dissolves, diffuses, dissipates, in order to re-
create; or where this process is impossible, yet still, at
all events, it struggles to idealize and to unify." The
imagination, moreover, is held to be "a repetition in the
finite mind of the eternal act of creation in the infinite
I AM". Our thought is immensely the richer for the Roman-
tic poets. Their work was essentially liberating and
spiritual.

Nor do I believe that in the twentieth century the freedom
of the artist has risen "to the point of absurdity" because
of his liberation from "all social responsibility." The
writings of Kandinsky, Klee, Gropius and Le Corbusier re-
flect intense concern to create forms embodying people's
social needs. They may have made mistakes but they made
them in pursuit of a rationale and we can scarcely ask more
than that the artist, besides making his object, should
write its apologia. The multitudinous art forms of our
time, even if they should prove to be emphemeral, at least
serve to express and identify powerful emotional and
spiritual forces that it would be unhealthy to suppress,
even if their expression is at times unsociable.

If the first reason for the stark view expressed in "The
Road From Wigan Pier" is that it undervalues the traditions
that feed current attitudes, a second is its preoccupation
with objects at the expense of attention to the processes
that give rise to them. I would put a contrary view. The
first business of art is making. If our concern with art
works of the past is so great as to stifle our making in
the present, then we are in a highly morbid state. The
great masters would become the ogres of our time, and it
would be our first task to destroy them. But I speak of
masterpieces that have moved me to tears, of Bach's "St
Matthew Passion" with its inevitable choruses, of the col-
onnade of Durham cathedral, of Rembrandt's presentation of
the shepherds in the stable where space emerges mysterious-
ly from the glances of half-light on roof rimbers. Yet if

this greatness should stifle creativity, then the works
must be discredited. Man comes before art. Even in saying
that, however, I am caught between admiration for the works
themselves and revulsion that they should be used, even un-
intentionally, to inhibit rather than inspire. The
"mysterious, rich and encompassing symbols" must not stifle
but encourage. That they can do both is their dialectic,
just as the identity of admiration and revulsion could be-
come mine.

The third point on which I have wished to take issue is the
spirituality of modern art. I see spirituality in the
working out of the dialectic. I would go further. As a
Christian I find my work as a teacher intensely sacrament-
al. Learning and skills are the outward and visible signs,
vision the inward and spiritual grace. Thus, if your pre-
fer the philosophical ring of a word like dialectic, let it
stand, but the oppositions it implies are close to the idea
of sacrament and I am not yet convinced that mythology is a
worse way of exploring vision than rational enquiry. Con-
flicts in dialectic generate myths which are perpetuated
by spiritual forces.

A dialectical approach strongly coloured Michael Golby's
discussion of "The Responsive School". As cultural units
(anthropologist's culture, not aesthete's) schools are
umbrellas concealing a number of internal conflicts; indeed
culture itself is not static though it provides a longer or
shorter lasting equilibrium. The equilibrium of the school
is poised on its conflicts. It is a national institution
but in a local setting. In terms of curriculum the schools
derive much strength from an academic tradition established
by comprehensives. Yet comprehensive is just what the
curriculum is not. Certain things are designated firmly as
beyond the pale and the criteria of exclusion and inclusion
are not necessarily based strictly on principles of learn-
ing. Some material, particularly if expressed in certain
styles or conventions is anathema. Such continual stress-
es put our schools in a state of crisis; in terms of
curriculum development, the way out is through prolonged
negotiation, the evaluation of which can never be final.

I stressed earlier that art is a process leading to an
object. The state in which we must live of uncertain
stance in the tenuous equilibrium of the constant-change of
permanent dialectic demands our attention as educators to

process, to the state of ever-becoming. Art as process is
very much Horace Lashley's concern when he deplores disre-
gard by the schools of the music of ethnic minorities. In
educational terms this is not strictly an ethnic problem
and I have argued elsewhere (1979) that the West African
novel can be of great service to the British adolescent;
the problem is one of sub-cultures. We are led back, un-
fortunately to the all-encompassing, crippling symbols.
Because Vivaldi is all right, the argument seems to run,
steel band is all wrong. Of course, Vivaldi is all right;
it is only all wrong when its all-rightness denies the all-
rightness of the steel band. No serious musician can use
Beethoven, or Vivaldi, or the raga, or anything else to in-
hibit the music of the steel band (Seid umschlungen,
Millionen - where are we, for Heaven's sake?), or rock.
But perhaps I make a mistake: serious musicians may reject
rock or steel band, it is serious people who cannot afford
to do so. The effect of "high" music (social sense, not
dionysiac) is to destroy the broad base of popular music-
ality. Black peoples dance. Their culture has this broad
base of popular musicality which is lost to modern Britain
and to most of modern Europe. It is expressed in the
dance, not merely in the set-pieces made up for export, but
in the sensuality and satire of the dancing in West African
bars, and, of course, in the sense of passional generation
which informs the dancing of traditional death ceremonies,
dancing in which everybody joins.

Popular dances and the sub-cultures of youth are genuine
art because they are forms which embody the stance people
adopt in response to the stresses of the dialectical press-
ures of their lives. Moreover the stances, just as art
is, are put into a convention in order to point the basic
necessities of the expression. If, failing to understand
this, we impose the remote and possibly alien symbols of
the past, we disjoin the internal necessities which gener-
ate art from what we continually call art. The result is
confusion, not least of the artistic process. The styles
of the young will play up to "high"-minded condemnation.
Here is an absurd statement (Forby, 1830) an attitude to
sub-cultures which no serious linguist could adopt today:

"To imagine that the vulgar fabricate
language for their own ordinary use is an
absurdity. They neither do, nor can think
of any such process. They take and use
whatsoever is provided for them; and that
provision is made, varied and improved by
the learned of successive ages. From them
it goes downwards, stamped with authority,
which may very properly be called <u>classical</u>."

An impossible stance for a linguist, but not, apparently,
for a musician: I hope its absurdity can be recognised.

"Stance" and "dialectic" are perhaps among the cant terms
of our age (as critics have used "relevant" and "valid"
carelessly); nevertheless, they reflect important truths of
our society: truths, moreover, to which the arts can min-
ister in a special way. The imitation of life in our times
is not the imitation of objects - we need not paint trees,
or people, or whatever. Art has media and conventions to
express the stresses of the dialectics through which in our
continually changing stances we dance. As we categorise
through contrasts, semblances, harmonies, discords, polar-
ities, identities, syntheses and dialectics (Witkin, 1974),
or mere confusion in our thinking about life, so in art we
work the same properties in media and conventions. In
drama, or sculpture, poetry, paint, dance, or music, we can
aim at serenity, hesitancy, chaos or cacophany. In con-
ventionalising our feelings art removes them from their
referents and displays their profound rhythms and struct-
ures. This process of symbolisation is not altogether
different in many respects from the forms of symbolisation
in higher mathematics. The media in art, the stuff of
thought, are more directly concerned with feeling, and the
mathematical analogy is perhaps more helpful to those who
do not understand the precise forms of art-thought than to
those who do. Broadly, art allows children to enter into
the process of symbolisation precisely because it tends to
divest itself of reference, the information we must have
before we can understand. Children can manipulate struct-
ures in a way not open to them in more information-intens-
ive activities (like the humanities). We live in a complex
and, on the whole, puzzled world, which needs all the
powers of thought it can muster and patently the aim of the

educator must be to encourage thought. The challenge to
politicians and education administrators is blunt. To deny
creative art in the school (and that includes setting up
the alternative of "design", unless it is understood as a
fully creative rather than merely technical activity) is to
deny a form of thought of immense value. If the administ-
ration cannot provide for this thought, then it is not the
thought that should be scapped, rather the administrators
or, if the case becomes really extreme, the whole administ-
ration.

A nearly final, practical point. The musical sub-culture
of the children must be brought into the schools. Insist-
ing on the classics to keep it out is to set up an
imposition which forces on children something they don't
understand and denies meaning to what they do. We should
not expel the classics - some adolescents derive intense
enjoyment from them - but neither should we use them to
expel other forms of music. This kind of conflict feeds
the schism between pupil and teacher, which is one of the
crises of our schools. In breaking down barriers tele-
vision could be a great ally. Some time ago the B.B.C. ran
a series of programmes aiming to find the young musician of
the year, and "The Best of Brass" is long established. A
similar contest to find the young band of the year would be
a powerful public relations activity for sub-cultures. For
the young it would also be an indication that important
people are interested in what they do. Even parents might
applaud something that occupied significant television
space. I offer the idea for anyone interested - independ-
ent television, perhaps?

I don't want to end with politics, but with the point fund-
amental to our knowing and being. The conventions and
styles of art are territories where we may explore the
stresses of the dialectics amongst which we live. The art-
efact is an object proclaiming the maker's stance. In life
to overbalance is disaster: art offers direct opportunities
for trying our balance and finding ways of correcting it.
Even, when the oppositions of the dialectic become compact-
ed in a single image, it can countenance the fall; we can
experiment to disaster to find the limits of our being,
that point where "Nothing is but what is not". Alternat-
ively, in creative dissolution we may in a release of
spirit annihilate

 "all that's made
 To a green thought in a green shade."

The image liberates being.

REFERENCES

Coleridge, Samuel Taylor. (1965) Biographia Literaria.
 Everyman, p. 167.

Forby, Robert. (1970) The Vocabulary of East Anglia.
 Charles, Reprints, pp. 11-12.

Shelley, Percy Bysshe. (1962) A Defence of Poetry in
 Enright, D.J. and de Chickera, Ernst, English Critical
 Texts. O.U.P.

Spurling, David. (1979) West African Fiction in English
 Secondary Schools, The Use of English, pp 39-44.

Witkin, Robert W. (1974) The Intelligence of Feeling.
 London, Heinemann, pp. 178-9.

The Arts and the Whole Curriculum

JOHN EGGLESTON

Perhaps we all have a predisposition to believe that the
arts have, or should have, a secure, unchallenged and cen-
tral place in the curriculum. The arts, after all, offer
experience in the essential qualities of developed humanity
- truth, beauty, integrity, taste, style and sensitivity.
How can their place in the curriculum be seriously ques-
tioned?

Yet as we know well the challenge exists and faces all who
teach the arts in the schools. There are at least two fun-
damental reasons. One is the existence of other subject
areas each of which also claims to offer experiences that
are essential for human development. And since the devel-
opment of the curriculum studies and curriculum research
movements of the 1960s and 1970s the capacity of the vari-
ous subject areas to articulate and argue their cases has
been notably enhanced. The other is that the media through
which the experiences of the arts are made available in the
curriculum - and indeed in society generally - are, unlike
the essential qualities, not eternal. Indeed they are oft-
en remarkably ephemeral. To maintain the place of the arts
in the curriculum the day to day activities of music,
drama, art and design have to be renegotiated regularly
with colleagues, students and authorities in order to main-
tain timetable space, staffing and resources. It is a ne-
gotiation that takes place with even greater intensity in
contemporary economic conditions. Present and future suc-
cess in such negotiations is likely to be determined by the
capacity of those who teach the arts to present and argue
their case: to justify the arts not only by their 'eternal
verities' but also by the important and often unique con-
tribution they can make to the curricula of young people in

58

contemporary society. Accordingly in this chapter I would
like to offer some arguments for the role of the arts in
the 'whole curriculum' - arguments which, I believe can
command wide acceptance. The arguments centre on three
concerns of the whole curriculum: the human environment,
human expression and preparation for work. Though closely
interrelated, I shall endeavour, for clarity, to disen-
tangle them here.

The Human Environment

One of the most central objectives of human societies is
'to preserve the environment' - both natural and human art-
efact - against which all human creative activity occurs.
Until recently we have believed that 'experts' in the arts
and other fields are best able to handle this problem. In
the past decade we have, however, come to realise that it
is the decision of all human beings, and not just those of
the experts, that determine the state of the environment -
as the mass campaigns of conservation, anti-pollution and
urban renewal have shown. The new realisation portends
great opportunities for the arts in the curriculum.

The longstanding patterns of curriculum have reflected the
traditional concept of a society where a few take decisions
and the majority are educated to follow them. Let us take,
as an example, the ways in which people are educated to use
recreational space and their own 'territory' in modern so-
ciety. For a quarter of a century schools have reinforced
the role of the 'expert' in town and country planning, the
arts, recreation, social services, housing and many other
categories of human activity. The concept of the expert is
that of a person whose training and experience allow him to
make the right decisions for the majority. The first task
of the school has been seen to be one of selecting a small
group of young people who have the capacity to undertake
appropriate training so that they themselves become experts.
The second task has been to ensure that the others will be
able to respond to the expertise of the experts and above
all to see their role as necessary and legitmate. Often
teachers who are committed to helping young people to maxi-
mise their creative and expressive potential still play a
major part in bringing about a suitable deference to the
experts. A recent case in the writer's experience may
serve as an example. In a comprehensive school a lively

and enthusiastic art teacher was running a highly success-
ful course of study for the 'leavers' class'. With them he
was exploring ways in which they could express themselves
in designing and producing their own distinctive living
space through creating furnishing, decoration and personal
equipment of all kinds. The emphasis was strongly on deci-
sion making and personal expression. Yet the culmination
of the course was a visit to the London Design Centre where
the group of students were shown the kind of interiors that
were really recommened by the 'experts'; the Design Centre
approved items that they should purchase and were told of
the approved sources where these items could be obtained.
In short the culmination of the course was, in a quite re-
markable way, a statement of the superior expertise of the
Design Council and its assessors.

Yet though schools have persisted with such traditional ap-
proaches for many years it is increasingly clear that they
are by no means effective in achieving their ends. Even
after a quarter of a century of town and country planning
we are faced with spectacular problems of conservation, en-
vironmental preservation and pollution. A vast number of
products bought for the home and for leisure are not those
approved by the Design Council. Leisure activities of
young people in dance, drama and music, are by and large
only infrequently those taught and approved by the schools.
The dress and other personal decoration worn by young
people is only rarely that recommended and endorsed by the
teachers of home economics, art and craft.

At the heart of the problem there seems to be a determined
desire on the part of individuals to make their own deci-
sions about dress, entertainment, possessions, property,
leisure and a wide range of other aspects of their personal
life. In short, a desire to act out their own lives. Re-
cently I was travelling by train and was looking at the
succession of back gardens of a modern and obviously 'well
planned' housing estate. The houses were unquestionably
well-designed and constructed and had an 'appropriate' de-
gree of variation that a wise planning authority had seen
fit to incorporate in order to avoid monotony and repeti-
tiousness. Yet this degree of variation was obviously
quite insufficent for the residents. In the back gardens
there was a flowering of individuality of a kind that would
bring distress to most planning offices. The gardens were
sprouting with sheds, lean-tos, terraces, patios, concrete

gnomes and much else. Not only was the variety remarkable
but the human effort that has been put into the work was
striking.

In leisure the same diversity is clearly visible. The move
from mass spectator sport to individualised participation
sport is well documented. It has even been noted that in
the remaining spectator sports such as Association Football
the amount of individual expression among the followers is
remarkable. If one visits one of the new style sporting
events one can marvel at the extent of individual decision
making that has taken place. At an amateur, as opposed to
a professional, motor race meeting one is impressed not
only at the variety of technological expression of a high
order that is to be seen in the vehicles but also at the
aesthetic expression that is to be seen in the colour and
the styling of the vehicles. Much the same may be seen at
a Karting Meet or at a Land Yachting gathering. This indi-
vidual expression or 'customisation' as Tom Wolfe puts it
is not of course confined to such meetings. It may be seen
in the way in which people of all ages and social groups
express themselves and make their own decisions about the
appearance of their cars and other personal equipment. A
glance through the pages of Custom Car magazine indicates
how widespread this expressive decision making through
leisure is. Reyner Banham (1971) has reminded us how the
very young with their Chopper bikes are involved in a very
similar process. Similar examples can readily be drawn
from other 'arts' areas - drama, dance, music and art.
Their potential contribution to the curricula and to the
development of human capacity is unmistakeable.

So far I have emphasised the powerful incidence of individ-
ual decision making in contemporary society. Yet it is im-
portant to emphasise that, although apparently idiosyncra-
tic, it has an important collective effect. Unquestionably
it is the widespread and extensive exercise of decision
making in this way that is the real determinant of the hu-
man environment in which we live. Increasingly architects,
town planners, housing and entertainment managers and
building developers are coming to realise the essential
truth of this. Recently one of our most eminent planning
consultants conceded that in his future development schemes
he would have to take cognisance of the insatiable desire
of people of all class and age groups to extend, modify and
individualise their homes. Increasingly too there is

evidence in certain situations that the powerful desire of
individuals to determine their human environment takes on a
new powerful, collective voice. Such an example arose aft-
er a recent disaster in the Ronan Point tower blocks in
London where an explosion severly damaged the accommodation
of many of the residents. The result was the development
of a very powerful challenge to the 'experts' by the resi-
dents who, for the first time, found themselves able to
communicate with the experts; to articulate and express an
argument with confidence and conviction. In recent years
the response of architects to this now widespread movement
has been remarkable.

Personal Experience

There is considerable evidence in most areas of modern
society and notably the arts of this enthusiasm to be able
to challenge the experts, to make one's own decisions; to
get 'off the receiving end' and 'contract into' decision
making. Impressive evidence of this arose in a recent
study on the Youth Service in England and Wales (Eggleston,
1976) conducted by the present writer. In extensive dis-
cussions with young people there was clear indication that
one of the most fundamental desires was to 'count for some-
thing' in society. Respondents were clearly aware of an
education that had often put them on the receiving end of
the professional entertainer and the commercial entertain-
ment industry, the foreman, the social security officer and
the whole gamut of experts in modern society. They wanted
to reach the situation where they were able to engage in
activity in which they counted for something and were ac-
cepted as doing so by adults and their peers. They search-
ed for leisure opportunities where this chance was seen to
exist. The remarkable amount of individual leisure devoted
to making music, drama, and dance is one area of evidence,
the energy put into community service organisations such as
Shelter, Child Poverty Action, Release and a variety of
other national and local bodies is yet another. Such act-
ivities helped young people to feel a sense of involvement
in decision making, participating in a collective challenge
to the decision makers and being helped to obtain the mean-
ings, ideas and words with which to make a point and the
confidence with which to use them. Yet it was important to
recognise that the desire of these young people to get 'off
the receiving end' was in no sense a revolutionary fervour.

Most were emphatic that they wished to count for something
or at least have the chance to do so in a society similar
to the present one; not a radically different one. The
call was for a wider distribution of participation and pow-
er rather than a new distribution.

In reaching the concept of power I have perhaps reached the
heart of the move to decision making in modern society.
Unless the individual feels he has the power to shape his
own life, his actions and his surroundings then not only is
he unfulfilled but also he can have no concept of community
in its contemporary sense. Indeed he may make the situa-
tion negative, adopting a not uncommon attempt to count for
something by acts of disruptive and destructive behaviour
in the community on the terraces, the public loos and in
other 'no man's land situations'.

The picture I have painted so far is one in which there is
considerable evidence of individuals making their leisure
decisions in a modern society. It is one in which they can
be seen to be striving for some kind of personal power with
varying degrees of success. If one now turns to the chang-
ing educational arrangements of modern communities one can
see response to these demands. The Schools Council Drama
Project conducted by Lynn McGregor is an outstanding ex-
ample. One can also see it in the curriculum of Physical
Education where emphasis is laid increasingly upon oppor-
tunities for participation in minority sports as well as in
the team games and athletics that for so long have domin-
ated the curriculum in secondary schools. Similarly
emphases on dance and movement have notably not only aug-
mented much of the traditional gymnastic curriculum but
also achieved a place in the curriculum in their own right.
The radically changed work in Design and Craft in many
schools has switched emphasis from traditional craft skills
to personal and community problem solving, decision making
and, above all, meaningful expression of ideas, feelings
and beliefs.

Preparation for Work

Sound economic reasoning reinforces such concerns for indi-
vidual decision making. In the past, the main economic
function of the school has been to produce armies of young
people with a capacity to undertake remembered skills and

to reproduce remembered knowledge. They have provided the
main bulk of the labour force in factory and office. In-
creasingly, computerisation and automation of various kinds
have provided more effective alternatives to human labour.
Even where they have not, the increasing costs of employing
large numbers of individuals to perform repetitive tasks
has forced 'labour intensive' industries into decline: the
recent history of the Post Office and British Railways
offers abundant testimony.

If human beings are to obtain employment let alone satis-
faction in modern societies they are increasingly called
upon to undertake activities that are distinctively human -
the development of new ideas and the adaption of existing
ones. These roles are not confined to executives and tech-
nologists; they exist far more widely. One of the key oc-
cupational roles for many school leavers is that of main-
tenance engineer or service technician. It is his job to
diagnose faults in the vast array of equipment in home,
office, farm and factory that characterises modern society;
to identify faults or to replace the equipment, to under-
take the necessary work, to organise a supply of spare
parts and often to be responsible for accounting, collect-
ing cash and arranging a work schedule in a variety of
locations. In short it is his task to make decisions -
often in a surprisingly expressive way.

It is a recognition of the economic as well as the social
necessity of educating human beings to express themselves
and to make decisions that characterises the current devel-
opments not only in the arts but also in the new humanities
curriculum, the new mathematics and even in Nuffield
Science. It is in the drama and in the humanities projects
of the Schools Council that some of the most interesting
preparation for decision making in work and in leisure has
been attempted. In these projects students are being
obliged to think out their decisions so that, faced with
decision making opportunities, in adult life they will be
equipped to make reasoned judgments and, perhaps even more
importantly, to be able to defend them.

One of the most important features of the curriculum activ-
ities discussed so far is that they can relate directly to
the students' present condition. Decision making and ex-
pression are not abstract processes; they must relate to
real issues and have a suitable urgency. The history of

school projects is all too often one in which the students
participate actively within the context of the school - yet
there is no visible relationship between the work in the
school and their everyday lives. As I have mentioned earl-
ier the dresses the girls make in the needlework period are
not often the ones they wish to wear in their leisure hours.
Yet the effort they are prepared to invest in their leisure
wear may be altogether greater than they are prepared to
invest in their school activities. All too often the social
realities perceived by the teacher in the school are quite
different from the social realities of the student's com-
munity in which his real decisions are being made. The
willingness of many students to 'please teacher' often masks
the dissonance.

A good example of this occurred in a youth club visited by
the writer. Like many other youth leaders the warden of
this club was under considerable pressure to add a specifi-
cally educational component to his programme. He had not
found this easy; members turned up enthusiastically on dis-
co nights but their educational aspirations seemed to be
minimal. But on one evening the leader was enthusiastic;
he explained that the girls had asked for a course - on
good grooming. He had immediately telephoned the area
youth officer and in no time at all it had been arranged
that a home economics teacher with a special interest in
this subject would run a course. The writer attended the
club during the third session of this course and it was al-
ready clear that things were not going well. The initial
group of girls had declined from twelve to six. The re-
sponse of those who remained was unmistakeably one of bore-
dom and antipathy. It was not hard to see why. The girls
were, by most contemporary standards, already well able to
handle make-up and had obviously progressed a long way in
their capacity to achieve the image they sought. The tea-
cher, however, seemed quite oblivious of this and was pre-
senting a basic grooming course that had unmistakeable con-
notations of the early 1950s. Much of what she was saying
was of enduring importance but, though it was coherently
and enthusiastically presented, it made little impact upon
the girls. For them she was 'out of touch'; she failed to
recognise the signals that the girls presented to her as
clearly as they could. As one of the girls said at the
coffee bar afterwards "The trouble with that teacher is
that she makes us feel so inferior".

The example is not intended to suggest that in the arts and
elsewhere in the curriculum helping young people to make
decisions we should 'sell out' to them, accepting their
view of society as being the only one or even the most im-
portant one. Rather it is that we must start where the
student is if we are to move forward with him in achieving
decision making whether it be leisure or any other aspect
of life. To paraphrase Bernstein, "if the consciousness of
the teacher is to be in the minds of the student then first
of all the consciousness of the student must be in the mind
of the teacher."

Yet preparing for decision making and expression in society
involves rather more difficulties than we have as yet ad-
dressed ourselves to. We must now return to the concept of
power. Let us consider a community project in a rather
run-down housing estate that constitutes a school's catch-
ment area. The older students may well have a local repu-
tation for indifferent or even anti-social behaviour. Yet
with an enthusiastic teacher it may well be that they come
to participate fully in a series of activities in the com-
munity - creating and running playgroups, street theatre
and children's entertainment, redecorating old people's
homes, helping the handicapped. As a result of this the
students will not only gain an experience of acting effect-
ively; they will also achieve recognition from the commun-
ity at large. The local newspaper will probably print
their photographs and comment favourably on their work.
Civic leaders may come to meet them and congratulate them.
Instead of feeling outsiders in the community they will
come to feel like insiders.

But where do events lead from here? It is quite probable
that the students and their teacher will soon reach the
limit of what may be done for the old people by entertain-
ing them, digging their gardens, decorating their homes and
helping with their meals. But they may well realise that
the old people have other and more fundamental difficulties
that cannot be solved by direct action alone. They may
have leaky roofs or blocked drains and find that the local
authority or corporation that provides their homes is tardy
about necessary maintenance. There may be difficulties in
the provision of the subsidised public transport to which
they are entitled. At this stage the students may plan and
execute other equally creative activities to solve these
further problems. They may write letters to the local

newspaper, petition the members of the local housing com-
mittee, seek interviews with the officers of the local au-
thority. In so doing they may find response to their
actions may be different. The local newspaper may redefine
them as a group of teenage trouble makers led by a 'radi-
cal' teacher. The local councillors, especially if they
are also members of the education committee or the school
board, may well complain to the school that this is an in-
appropriate activity for its teachers and its students.

Here we have reached one of the fundamental issues of edu-
cation. If it is to help young people to reach a percept-
ive appraisal of their environment, to make decisions and
to express themselves, to identify their needs and argue
them effectively, then it is equipping them to claim and
exercise personal power in society. Yet as the example
makes clear, such a claim, to be effective, may need to
challenge those who already hold power in community and so-
ciety.

At such a moment the teacher and those who run the schools
must keep their head and not run for cover. The evidence
of the Youth Service Project was very clear - the call was
for a wider distribution of power rather than for a new
distribution. Certainly it is arguable that in the power
structure of most industrial societies redistribution is
possible without fundamental change. It is not difficult,
for example, to envisage many more people playing a part in
the considerable power exercised by workers' unions, local
government bodies and many 'pressure groups', perhaps most
notably the arts pressure groups. Some schools have re-
ported that a number of young people who learned decision
making and taking responsibility through such curriculum
activities have already found opportunities for active par-
ticipation in the affairs of their union or local govern-
ment.

Perhaps the fundamental feature of the new curricul epito-
mised by much of the new work in the arts, is that such
'acting out' in the school can lead effectively to 'acting
in' work, leisure, community and adult life in general. It
can not only lead to fuller expression but the perception
and creation of wider opportunities wherein it might be ex-
ercised.

Having implemented such approaches two further tasks remain

for the arts educator. One is to demonstrate the quality
of what has been achieved through the use of evaluation
techniques that are seen to be valid by colleagues, stu-
dents and the wider community. The problems of evaluation
and assessment in the arts are substantial and have been
the occasion of much distortion and error in the past: for-
tunately they are the subject of another contribution to
this volume and need not be considered here. The second
task is for the arts educator, so armed, to convince coll-
eagues of the central place of the arts in the whole cur-
riculum. In so doing he will need precisely the same de-
veloped skills of fluency, articulation and debate that he
will have been helping his students to achieve. He too
will need to learn to exercise power: not always the hall-
mark of the arts educator in the past. I hope that this
chapter and indeed the whole volume will, above all else,
help and encourage arts educators to develop and use a
more effective voice in the schools than heretofore.

REFERENCES

Banham, R. (1971) 'Had I the Wheels of an Angel', New
 Society, 12 August.

Eggleston, J. (1976) Adolescence and Community. London,
 Edward Arnold.

Eggleston, J. (1976) New Developments in Design Education.
 London, Open Books.

Education and the Arts

SIR ROY SHAW

Perhaps I should begin by explaining that my own background
is that of a university adult education teacher of philos-
ophy and literature, later a Professor of Adult Education
and later still Secretary-General of the Arts Council.
Throughout my career I have been concerned with the arts
and at the beginning of it found myself defending them
against the attacks of hard-headed Yorkshire adult educat-
ors who believed that economics and local government were
the real thing and the arts a decorative frill at best and
a dispensable luxury at worst.

This is perhaps why, before I came to the Arts Council, I
found myself lecturing on the question "What use are the
Arts?". The lecture is not a very good one but it's the
best I know on the subject! Few other people seem to have
faced the question and many of my friends most active in
the arts and education are in no better situation than the
French poet and artist Cocteau who said: "Poetry is indis-
pensable - if only I knew what for".

We are limited by our experience and the experience of Rob-
ert Witkin and Malcolm Ross is very different from my own.
This means I have learned a good deal from them, it also
means that I want to argue with them on some points which
will become clear as I go along.

I want to begin by talking about age and its effect on ed-
ucation and the arts, proceed to talk about the alleged
conflict between education which centres on expression and
that which centres on appreciation. Finally, I want to
look at a topic which has concerned me deeply throughout my
life both as an educationist and now as an arts administra-

tor: the dilemma which is posed by two succinct words used
by one of my predecessors: raise or spread?

AGE, EDUCATION AND THE ARTS

My concern here starts from almost the opposite end to that
at which Malcolm Ross starts. Which is not to say that
either of us is wrong; I hope rather that it means that our
approaches are complementary. Malcolm Ross begins with the
baby. I start with the adult. I think that educational
thinking is short-sighted if it concentrates only on youth
and forgets, as one of the excellent teachers writing about
a secondary school art course says in Malcolm Ross' book
(1978), that "the school's end product is not the 16 year-
old or his produce". I must confess that I have been dis-
appointed in moving among arts people whether they be act-
ors, writers or musicians who when they do think of educa-
tion, always think only of children and schools. Of course
it would be wrong to neglect children and schools, but to
limit one's horizon to the age of 16 is to be blinkered.
Forty years ago Sir Richard Livingstone (1942), then one of
our leading educationists, pointed out that it was as un-
natural to end one's education at the school-leaving age as
it would be to die at that age. When still a student he
was the first writer I met who emphasised that youth was
not always the best time to learn and that indeed some of
the broadly cultural subjects like literature could prob-
ably be more profitably studied by adults. I was later to
test this out in practice and found Livingstone had been
entirely right. However precocious school boys and girls
may be these days, they are not equipped to respond to, say,
Shakespeare's Othello, as can an adult who has experience
of mature love, marriage and jealousy.

None of this is intended to discourage the efforts of those
who are occupied in the education of children, but rather
to argue that this stage of education is the beginning and
not the end. There is life after school - lots of it! The
ancient Greeks had a saying: call no man happy until he
dies, and this was a simple straightforward way of express-
ing what can be called the teleological approach to life.
The same could be said of education, call no man educated
until he is really mature. Acceptance of this view changes
one's approach to the education of children. One doesn't
attempt to cram into them in their first 16 years of life

the educational equipment which will see them through life.
To do that is as misguided as thinking that you can cram
enough food into a child in one day to last it through a
month. If education is to nurture what D.H. Lawrence
called "the whole man alive", then we need to take long
views, in other words, teleological views.

Curiously, the teacher I quoted was unconsciously echoing a
remarkable insight about the arts in a Government report on
adult education published in 1919, at the end of the First
World War. Remarkable because this was at a time of great
preoccupation with social, economic and political problems.
Emphasising that adult education should encourage music,
literature, drama and craftsmanship, it concluded: "The
test of education is not what children do in school, but
what men and women enjoy out of it". Again, let us not
misunderstand this remark, it is not intended to disparage
what children do in school but to emphasise that the final
test of it comes after school, and relates not simply to
the work they have to do in school but the things they en-
joy doing in maturity.

Part of the problem of course is that parents too think of
education as something for children and not for themselves.
Just before I joined the Arts Council I directed an attempt
to penetrate a mining village where the adults had testi-
fied in a survey that they had no interest in education.
When this was quoted in the press a miner's wife wrote in-
dignantly to say that of course they were interested in ed-
ucation - for their children. I accordingly started
courses for parents in the literary texts which their child-
ren were discussing at CSE, O and A levels. The tactic was
to say that this was simply to help them to help their
children and of course there was no intention of educating
them! The device worked and led people to prolonged study
who would never have come near it if we had not pandered
initially to their prejudice that education is for children.
I can also affirm from my experience in adult education
both as a teacher and as a director of other people's teach-
ing, that the idea which is current in some places that the
shades of the prison house descend so much on the school
leaver that he or she is impervious to educational influ-
ence in later years and perhaps especially to the influence
of the arts is completely wrong. I have already said that
adults may often make better students than children, but
now will go further and say that sometimes school, far from

turning children "on" to the arts turns them "off". I re-
member a report a few years ago on early school leavers
said that the subject which early school leavers least want-
ed to touch ever again was - music. I talked about this
with a Schools Council committee and they told me that mus-
ic was one of the worst taught subjects in schools. I
don't know that myself, but certainly some very bad teach-
ing must have been going on to make music, of all things,
so distasteful.

To sum up this section of my talk, I am saying not only
that many a good tune is played on old fiddles but that
some of the best sounds come out of old fiddles and that it
makes a great difference to our approach to teaching child-
ren if we think of them as people who will go on living
probably three times as long after school, when they should
be exposed to further educational influences appropriate to
their stage of development and interests.

EXPRESSION VERSUS APPRECIATION

I have said my experience is in English university adult
education, I should confess to you that this experience has
been not only rich and rewarding but also constraining.
For many years in such work the teaching of the apprecia-
tion of the arts was approved by the DES which provided the
money, but practical work was not. There was a story a-
round which may or may not be true but if not, it was well
invented. It told of an HMI visiting a music summer school
who confessed himself to be impressed by the lectures and
discussions which he had heard: but, he warned: "One toot
on a trumpet, and bang goes your grant!" That attitude has
changed, whether by a change in the DES' regulations or by
gradual realisation that the old attitude could no longer
be maintained, I do not know. However, appreciation still
looms larger in adult education provision than does creat-
ive work, for every one course on creative writing there
will be a score on the appreciation of literature.

I detect on reading Witkin and Ross and in talking to
teachers that the emphasis is quite the other way round in
school teaching and that there indeed appreciation is al-
most a dirty word. Indeed Witkin does not use the word but
talks rather of 'the use of realised form'. Is it a pre-
judice on my part that makes me read this as though it were

parallel with talking about the wearing of ready-made
clothes? My own view is that training in creativity and
self-expression and in the appreciation of the arts are both
necessary and that to oppose them would be to make the mis-
take of saying either/or when the right approach should be
both/and. So I find myself reacting strongly against the
following remark of a community artist working with adults:
"Hanging a picture on a wall and inviting people to come and
look at it is the easiest possible thing to do. We are try-
ing to do something much harder: to tap the creativity of
everyone". I would retort that tapping the creativity of
everyone <u>can</u> be a euphemism for encouraging facile self-
indulgence and that really looking at a picture on a wall
can be a demanding experience. Do not critics of serious
art often complain that it is too "difficult". I cannot
help recalling that when arts patronage began during the war
it was very much stimulated by one of my most distinguished
predecessors who was then based in adult education, Sir W.E.
Williams. He recalls a clash with Lord Keynes, the dis-
tinguished Chairman of the Council for the Encouragement of
Music and Art during the war and of the Arts Council after
it. Keynes, according to Williams, thought it was unneces-
sary to have guide lecturers at CEMA art exhibitions because
"visitors could and should do their own interpretation".
Williams' comment in his book <u>Aims and Action in Adult Edu-</u>
<u>cation</u> (1921-71) on this is sharp:

 "There was, alas, in this great scholar and art connois-
 seur, a streak of donnish superiority and a singular ig-
 norance of ordinary people. The Institute time and time
 again reminded him that we were not a mere provider of
 touring exhibitions, but an educational body with a
 mission to enlighten people about art. "

I myself argue that there is something creative about a real
encounter with a work of art and rejoice to find Ross (1978)
agreeing with me when he says that perception (of a work of
art) is a creative act. My friend Richard Hoggart put the
matter in a more homely but striking fashion when he said
many years ago that once you have really experienced Shake-
speare's <u>King Lear</u>, you cannot even fry the breakfast bacon
in quite the same way again!

Again, I am pleading for a balance between creative expres-
sion and a creative response to a great art of our time and
past ages. We all know the dictum that "The artist is not a
special kind of man, but every man is a special kind of
artist". It is usually attributed to the late Eric

Gill, but it was in fact quoted by him (very often) from an
Indian writer Ananda Coomaraswamy. I have quoted it many
times myself, but with diminishing conviction. As long as
it is used to champion the cause of giving every child and
adult the opportunity to discover their creative abilities,
well and good; but when it is used, as it often is, to deny
the special gifts of the great artist, the genius, it sure-
ly contradicts the facts of life. Most of us may be able
to produce some kind of art, but most of us will produce
work that is markedly inferior to that of the professional
artist - certainly that of the great artists. Democratic
impulses may lead many to echo (was it?) Kipling's cry:
"Make no more giants Lord/But elevate the race". But in
the arts the Lord or someone is constantly making giants
and it is perverse egalitarianism which makes us reluctant
to acknowledge their greatness. Needless to say, I am de-
lighted by efforts to elevate public taste to the level
where the vision of the giants in all the arts can be per-
ceived and enjoyed.

You may be interested to know that there is an adult equiv-
alent of the "creative expression" enthusiasts in the arts
world. These are the community artists, who more than most
arts providers have a philosophy of the arts and of society
and the place of the arts in it. They sometimes talk about
the contradiction between those who emphasise art products
and those who emphasise the art process. Again to me this
seems a false anthithesis.

RAISE AND SPREAD?

What I have said sounds to some undemocratic, what I shall
now say will seem worse; but I will protest that I am re-
jecting only naive and crude interpretations of democracy,
and that like E.M. Forster I am quite prepared to give at
least two cheers for democracy. It is the best way of
arranging political life that anyone has thought of, but it
does not seem to me therefore to follow that it is the best
way of organising artistic life. Popular vote may elect
the best man to go to Parliament, but it can scarcely elect
the best artist. If it did Pam Ayres would have to be re-
garded as a better poet than Philip Larkin - and the Sun
would have to be accepted as the better newspaper than the
Guardian.

There are quite a few people working in the arts field both

in this country and more particularly in France, who would
disagree with me. They would argue that the democratisation
of culture - making the best of the arts available to more
people - must be replaced by cultural democracy by which
they mean cultivating arts work at the grass roots and en-
couraging people to express themselves. John Lane, who
spoke earlier in this Conference, has written that the ex-
periments of the late 'sixties demonstrated "the validity
of the self-determining, democratic processes and the over-
riding significance of 'doing your own thing' ". Now, I
have indicated that I think there is a very important place
for doing your own thing, but I would not accept that it is
overridingly important and to be preferred to a real under-
standing and enjoyment of great works of art. Many deny
this however. Sue Braden (1978) in the book on Artists and
People argued as follows:

> "It must be understood that the so-called cultural heri-
> tage which made Europe great - the Bachs and Beethovens,
> the Shakespeares and Dantes, the Constables and Titians
> - is no longer communicating anything to the vast
> majority of Europe's population... It is bourgeois
> culture and therefore only immediately meaningful to
> that group.
>
> The great artistic deception of the twentieth century
> has been to insist to all people that this was their
> culture. The Arts Council of Great Britain was est-
> ablished on this premise. "

I admit that the Arts Council is based on this premise, but
so are schools, universities and the BBC, to name but a few.
And the premise seems to me not to be a deception but to be
a declaration of the true state of affairs that the arts
belong to all mankind and not to a special group. If it is
not immediately meaningful, this is usually because people
lack the education experience to "possess" a work of art.
For this I have to say that the schools are sometimes re-
sponsible. The first White Paper on arts policy published
in this country (1966) claimed that "Too many working people
have been conditioned by their education and the environment
to consider the best in music, painting, sculpture and lit-
erature outside their reach". (I assume the omission of
drama was simply a drafting error!) It is quite true that
Shakespeare, Dante, Constable and Titian may have nothing to
say immediately to many ordinary people but it is not true

that they must remain outside the reach of such people. I
can speak with strong feeling from experience. First my
personal experience as a late developer in the arts, simply
because my early education was interrupted and it was sev-
eral years before I went on to higher education. My child-
hood was in a home where there was no music, no literature,
no introduction to the arts - not even a radio for several
years - and only one's richer friends had gramophones in
the house. I can well remember the time when the word op-
era meant to me what it still means to many working people
in the north of England whence I came: an excruciating
noise rather than an exquisite experience. But my own ex-
perience shows that if you cannot make a silk purse out of
a sow's ear, at least you can extend the range of most
people's appreciation and enjoyment. Moreover, profession-
al experience as an adult educator means that I have seen
countless cases of people discovering in their thirties,
forties, fifties and even sixties, great enjoyment in art
which had hitherto been entirely outside their range. To
sum this up then by saying that great art may not be
immediately available to people with untutored taste but
that teachers can be the mediators who can help people to
see (and hear) what is eventually, though often not
immediately to be found in a work of art. I have seen
Richard Hoggart spend an hour expounding a short poem of
T.S. Eliot to a group of middle-aged ladies and I have seen
their eyes open - or more accurately have seen their minds
opening. Of course, I am not in any way defending bad
teaching about the arts; rather do I think of introducing
someone to the arts as being analogous to introducing one
person to another where living and creative relationships
can be established.

So I reject the views of Miss Braden which I quoted above
as politically inspired philistinism at best, and advocacy
of a form of cultural apartheid at worst - advocating a
sort of Bantu culture for the lower orders. Arts patronage
by the Government in this country began with a slogan "The
best for the most". Some of those who invoke the title of
democrats seem to believe that the most are incapable of
appreciating the best and so you must give them something
less than the best specially prepared for their weaker con-
stitutions. However, they grossly missuse the word "elit-
ist" by using it to smear anyone who champions traditional
arts or high standards in them. These so-called democrats
are elitists in the proper sense of the term. They agree

with cultural snobs that the high arts should be preserved
for the elite, a privileged few and the rest of the popula-
tion should have something else.

So to sum up this section I would say that the apparent
tension between raising the standard of the arts and
spreading them to more people, is a tension rather than a
contradiction. You can both raise and spread, and indeed
in a democratic society you must. You can escape the ten-
sion in which I have lived all my life as an adult educator
and now as an arts administrator by plumping either for the
"best" or the "most" but only if you put the two together
do you have a sensible arts policy, and I would suggest a
sensible educational policy.

 CONCLUSION

Lord Recliffe-Maud in a report on arts support, three years
ago, made the point that arts providers and education pro-
viders are "natural allies". They are increasingly working
together, but still not enough. For example, a study of
children's theatre published by the Arts Council earlier
this year found that only one half of the children in
schools get to the theatre once in a year. I find that an
extremely depressing statistic, however much drama is going
on in schools.

To end on an up beat, however, I would like to refer to two
very encouraging instances, one very recent, one over 70
years old. Recently, the English National Opera North
Company was presenting Carmen. They sent their Carmen,
with other members of the company, into schools. The
children rehearsed with her as chorus, scenes from the op-
era. All this as preparation for a visit to the opera.
The children responded joyously to the approach.

Finally, I should like to quote the testimony of an old man
several years ago, looking back on his experiences at the
beginning of the century, in one of the first university
tutorial classes, taken by that great social historian,
R.H. Tawney (1908):

"The class meeting is over, and we sit at ease, taking
 tea and biscuits provided by member's wives. Talk
 ranges free and wide - problems of philosophy,

evolution, politics, literature. Then R.H. Tawney
reads to us Walt Whitman's <u>When lilacs last in the
dooryard bloom'd</u>; this moves a student to give us
his favourite from the same source; <u>Pioneers! O
pioneers!</u> Another follows quoting from a poem of
Matthew Arnold that evidently has bitten him, one
ending with the magic line, <u>the unplumb'd salt
estranging sea.</u> And for some of us as we sit
listening a new door opens. "

At school we are opening the doors of perception and creat-
ivity. The passage I have just quoted is a powerful remind-
er that new doors should and can go on opening throughout
life.

REFERENCES

Braden, Sue. (1978) <u>Arts and the People.</u> Routledge &
 Kegan Paul.

Ross, Malcolm. (1978) <u>The Creative Arts</u>. London,
 Heinemann.

Witkin, R.W. (1974) <u>The Intelligence of Feeling</u>. London,
 Heinemann.

The Concept of Art

VICTOR HEYFRON

'Nothing is positive about art except that it is a concept'
Richard Wollheim (1968) 'Art and Its Objects'.

If, as Wollheim (1968) argues in Art and Its Objects the
concept of art is not innate but learned, then the success-
ful acquisition of the concept depends upon certain exper-
iences which the child undergoes, namely, those experienced
in an art environment. For talk of the successful acquis-
ition of the concept of art suggests evaluative criteria by
reference to which we are able to recognize the adequacy or
inadequacy of a person's understanding of the concept of
art. These criteria are never the provinces of one person
(e.g. the teacher's) but rather they are embedded in the
objects which artists make and the practices in which they
engage, and by reference to which the child comes to recog-
nize that his experiences are correctly described as art-
istic. The description of an activity involves concepts.
I shall be concerned in this article with the role concepts
play in regulating the making of art object, and in par-
ticular I shall argue that the art education of the child
consists in helping him to acquire an adequate understand-
ing of the concept of art as articulated and elaborated in
public art objects. But before doing so, it will be useful
by way of introduction to consider the implications that
teacher's and pupil's notions of art have for the learning
context.

Lest the reader mistakes my intentions it is worth issuing
a disclaimer at the outset. By stressing the conceptual
importance of established art objects and practices, I am
not suggesting that there are absolute standards in art or
that one is able to gain insight into the arts other than

by testing out works of art in experience. Nor am I sugges-
ting that there should be excessive or uncritical attention
devoted to conventional techniques and so-called examples of
'accepted art'. Rather I shall argue that the individual
should forge his own style from out the elements of art,
guided by the concept of art. Malcolm Ross speaks of the
raw materials of self-expression - how to paint, how to
make music, how to dance. The concepts regulating artistic
practice are ultimately experienced in art objects, and the
acquisition of art concepts is never a purely cognitive
matter, rather it involves what Louis Arnaud Reid (1976-77)
has described as 'cognitive feeling'.

First then, the teacher's notion of art. The recognition of
the adequacy of the teacher's understanding of the concept
of art does not rest ultimately on his command of language
in an artistic or aesthetic context but rather in the sort
of existential commitments he exhibits in connection with
the elements of works of art. It is obvious, that together
with other considerations (e.g. knowledge of child develop-
ment and pedagogic methods), the teacher's concept of art
regulates the type of activities, programmes, and methods he
introduces (or does not introduce) into the classroom. Also
his understanding of the concept of art affects the type of
criteria he chooses to assess the aesthetic development of
his pupils. The implications for the practice of the teach-
er without an adequate understanding of the concept of art
are obvious, namely it is likely he will be unable to help
the pupil locate his experience of art in a wide perspective
For example, the pupil may be introduced to a number of ex-
citing basic design techniques, but because they are intro-
duced in such a way as to ignore the unifying concept of
art, the activity will tend to appear disjointed and unre-
lated to any other experiences in the art area, i.e. an
isolated experience with little reference to the wider
sphere in which the concept of art operates.

Secondly, if we accept that the particular concepts that a
person has of an activity regulates that activity, then the
ideas the pupil has concerning the nature of art will also
affect his response to the elements transmitted in an art
lesson. For example, the art teacher will be confronted
with children who already possess a notion of art. And in-
itially the pupil will tend to want to fit in any new act-
ivity the teacher introduces to his notion of art. It is
worth noting that his notion of art is gained in a variety

of ways. It may indeed have been acquired in association
with adults who are dedicated artists, but, it is more
likely that it is the outcome of commerce with popular lit-
erature, pop music, comics, colouring books, advertisements,
book illustrations, and stereotyped portrayals of artists
in the media. The criteria the pupil uses to ascribe value
to work may be restrictive, for example, there may be a
premium on technical skill or knack, or the ability to pro-
duce photographic-type resemblances of objects; also, he
may deny that some established art activities fall under
the concept of art at all (e.g. movement, photography, and
film).

It is important for me to stress that I am arguing that a
child can be unsuccessful in acquiring an adequate under-
standing of the concept of art, and that this will interfere
with his aesthetic development. What I am not doing is
adopting any substantive ideological position as to what
would count as a lack of success in acquiring the concept
of art. It is in art teaching contexts that a person's
understanding of what counts as a successful acquisition of
the concept of art manifests itself, and this understanding
will be reflected in the activities which he introduces to
the art context and the judgements he makes about the
pupil's work. The reader must examine his own practice for
a substantive description of the concept. However, I will
attempt to illustrate below the formal components of the
concept of art.

What do we mean by the concept of art? Would it be more
accurate to speak of a concept of art rather than the con-
cept of art? The notion of a concept of art seems to sugg-
est that there are a number of competing concepts of art,
and that there could be as many concepts of art as there
are people engaging in the arts. There is a sense in which
this is true, but one implication of holding this to be the
case is that there could be no independent criteria on the
basis of which we would be able to adjudicate between these
competing concepts of art, for example, on this view the
young child's concept of art is merely different from the
teacher's. As a matter of experience we do believe we are
able to contribute to the artistic learning of the child
and to recognize when he makes progress in an art activity.
If we didn't believe this then there would be no point in
setting up art education establishments! As teachers we
don't want the pupil merely to absorb our distinctive views

of art. We want him to develop his own views. In our
teaching we implicitly appeal to the concepts embedded in
established art practices and art objects. Wollheim argues
that we come to recognize these objects as works of art be-
cause they were produced under the concept of art. He
writes:

> "in the making of any work of art a concept
> is operative. It is not simply that in
> describing a work of art after the event, as
> it were, we use concepts to characterize
> them or catch their characteristics: but the
> concepts have already been at work in the
> artist's mind in the determination of these
> characteristics. Indeed, one criterion of a
> description's adequacy is that in it the
> concepts that have helped fashion the work
> reappear. "
>
> 'The Work of Art as Object' in 'On Art and
> Mind', Wollheim (1973).

In what follows I shall elucidate the notion that concepts
regulate practice in connection with the claim that art ed-
ucation is concerned with helping the child to acquire an
adequate understanding of the concept of art. By emphasiz-
ing the concept of art rather than a concept of art, I am
suggesting that it is possible for the venture to be un-
successful. A person could not be unsuccessful if either
the concept of art was innate, or if it were peculiar to
each individual person. If it were innate it could mani-
fest itself whether or not established art objects or prac-
tices existed. And if it were peculiar to each individual
we would have no independent criterion by which to deter-
mine its presence, or standards to judge its successful ac-
quisition, for it is possible on this argument for it to be
totally different for each person. Of course, a person
could be unsuccessful in this last sense if he didn't have
a concept of art at all! But this state would be similar
to the person's with no understanding of language, in the
sense that it is difficult to conceive of that state, or
the sort of criterion appropriate to identifying putative
'private' concepts of art. Surely, what we would have to
mean by saying that a person had no understanding of art is
that he didn't know how to relate to established art ob-
jects or to engage in established art practices, i.e he

doesn't know how to relate to paintings, poems, films, or
how to appreciate these objects as works of art, or how to
adopt an aesthetic attitude towards natural or man-made ob-
jects. And if this was the case, there would be more lack-
ing than just the concept of art! In the same way as it is
difficult to conceive of a person existing in our society
without some understanding of language, it is difficult to
conceive of a person totally ignorant of art objects and
practices. The main point emerging from this discussion is
that recognizing lack of success depends upon the existence
of established art objects and practices.

If then a person isn't born with a concept of art but ac-
quires it as a result of an initiation into a culture which
possesses that concept, then an adequate description of an
activity in which a child engages under the concept ulti-
mately depends upon the grasp of public practices and pro-
cedures; and it is in relationship to these practices that
one is justified in making the claim that the child has
been successful. The child's success depends upon him
coming to understand that what he is doing in an art activ-
ity falls under the concept of art, and this understanding
consists in him having grasped the appropriate concepts in
that area; and to have recognized in the work the presence
of more general concepts. In order for a child engaging in
an artistic activity to recognize what he is doing (in that
activity) he must make reference either explicitly or im-
plicitly to concepts both descriptive and regulative of his
activity. For example, the child comes to see that the red
mark on the paper is the brushstroke of a painting and re-
presents mummy's smiling face, and that the upward movement
of an arm is an element in a dance and the expression of
grief. That is, a child comes to recognize that a particu-
lar mark within the totality of a work represents X or ex-
presses Y because he understands the larger process of which
it is a part. These processes fall under, and are embraced
by, the concept of art.

Wollheim likens the concept of art to the general knowledge
of language we have to presuppose a child possesses in the
language lesson, (for example, he understands the notion of
rule and has the capacity to apply grammatical categories).
He writes:

 "Monsieur Jourdain was ridiculed by Moliere
 as one who all his life had spoken prose

without knowing it. Monsieur Jourdain had
the concept of prose. (It) directed his
speech, though he never consciously applied
it to his speech in description of it. Sim-
ilarly I shall choose to think of the pupil
in the art lesson who can benefit from the
lesson as having the concept of art."

"The Art Lesson" in 'On Art and Mind',
p. 150 (1973).

Wollheim is saying that if the pupil is to make sense of
the elements transmitted by the teacher in the art lesson,
then the pupil must have artistic concepts regulating his
activity. The claim raises the question: on what basis
does the child learn to choose this mark rather than that?
It would seem that if the child recognizes the fittingness
of the teacher's suggestion: X rather than Y, then the pup-
il possesses a criterion on the basis of which he is able
to see the X element fitting into the overall pattern of
his work. In other words, he has a concept regulating the
organization of the various elements in his work: a concept
which the teacher presupposes in his teaching. For the
fact that the teacher presented a particular view about the
way the pupil should proceed is never a sufficient justifi-
cation for accepting advice, ultimately it must be the pup-
il's judgement that the mark is the correct one. It is ul-
timate in the sense that the pupil sees the point of the
teacher's suggestion within the pattern of his work: and he
is not persuaded by, say, the authority of the teacher's
position. It is difficult to make this point in such a
brief space without distorting the subtlety of Wollheim's
argument. However, an example should illustrate the point.
Imagine a child painting a picture of a landscape. The
teacher invites the pupil to make the trees look at a dist-
ance by lightening the tone of the background. Seeing the
point of the teacher's suggestion presupposes the pupil
understands the artistic practice of representing three di-
mensional space in a painting, and further recognizing that
wanting to capture the illusion of depth in a picture is a
legitimate aim in painting. Without these assumptions the
prescription would be unintelligible to the pupil.

So far, we have suggested that the concept of art is not
innate, but something we learn as a result of being

initiated into a culture which possesses this concept em-
bedded in its institutions, aspects of which we have to
presuppose in the learning context. We are left with the
following difficult questions: (1) what are the identifying
features of the concept of art? and (2) how does the con-
cept of art manifest itself in the experience of the pupil?
Let us turn to the first question.

Whatever the substantive content of the concept of art it
is surely a highly complex one, embracing specific concepts
individuating different art areas and general concepts
bridging art areas; also it includes elements exterior to
the arts, (e.g. life values and technology). We might
think of the concept of art as a complex network of inter-
locking concepts, attitudes, skills and practices, a des-
cription of which would require a description of a whole
way of life (Wittgenstein). If there is a concept of art,
and not merely a set of disparate concepts sharing the term
'art', then it must have some kind of unity however loosely
characterized. We could think of this unity as consisting
in the fluid and dynamic patterning of elements as <u>exper-
ienced</u> in the work of art. Even though these interrelated
elements organize themselves differently in different art
activities, the concept has a formal unity. Its substance
is as constant and as fickle as human nature. In a work of
art, the elements will vary as between works, and the gen-
eral concepts in a work will tend to make that work look
outwards towards other works. For example, the general con-
cepts of naturalistic representation, truth to materials,
and harmony regulate the production of a range of art works,
but the concept of 'red rather than blue' only makes sense
within the context of one particular work or style.

We cannot place too much weight on the notion of unity, but
it does point up a formal capacity that only comes to fru-
ition in the sensing of the art object. For example, the
first notes of a musical work sets up the formal pattern of
what is to come in that work. If I see this pattern, I
know how to go on, and this means having the relevant con-
cepts. These concepts provide us with the capacity for
sensing what is in the work, and we exercise this capacity
when we 'experience the concepts' in the work. The sub-
stance of the concept of art is revealed in art works and
practices when the spectator allows the work to 'act like
art in experience'. It is then that the concepts he brings
to the context are united with the concepts structured in

the work.

We have referred above to the notion of specific and general concepts (or in Wollheim's terms lower and higher concepts).

These concepts form a hierarchical structure. They may have linguistic analogues, but they are not merely verbal descriptions. For example, the following concepts regulating the production of the portrait of Daisy May (see plate 1) suggest themselves in descending order of generality in the experiencing of the work: the concept of art; naturalistic representation; figurative; portrait; expressive forms; protrusions, convexes and concaves; smooth and textured surfaces; terracotta clay into bronze. The particular protrusions of the portrait are specific to that head, and fall under expressive forms, and this concept in turn falls under that of naturalistic representation. That is, we couldn't have naturalistic representation without expressive forms, and we couldn't have expressive forms in a three dimensional work without protrusions. We haven't space to discuss the nature of this connection here (e.g. Is the connection a contingent, causal, or formal one?), but we can see that the higher concepts (e.g. naturalistic representation, figurative) depend upon the lower concepts (e.g. protrusions) for their manifestation, and the lower concepts depend upon the higher ones for unification. The illustration is expressed in the formula: in order to experience the lower concepts in the work we must have the capacity to experience the higher ones, for it is the higher concepts which provide an organizing principle; and in order to experience the higher concepts we must be able to experience the lower, for it is through the lower that the higher concepts are manifested. Discussion would reveal that there is considerable overlap between higher and lower concepts, and that the whole issue of the interrelatedness of the hierarchical structuring of the concepts in a work of art is more complex than the simple description of the portrait suggests. The principle of hierarchical interrelated concepts operates with respect to all works of art. A criterion of a person being able to relate to the work is that he possesses concepts regulative of that work, or at least sufficient to experience what is in the work. The concept of art regulates the spectator's appreciation insofar as he brings sub concepts to the work and experiences them as organized in the work. For example, in the

portrait it is safe to assume that whilst certain artists
possess concepts regulating the belief that focussing on
the figurative interferes with genuine artistic concerns,
most people will be able to relate to the portrait because
naturalistic representation figures prominently in their
understanding of the concepts of art. Only some portraits
figure in the 'discerning' artist's concept of art, for ex-
ample, those which emphasise the formal elements of the
work. On the other hand, many people will believe that
non-figurative abstract constructions are not art because
non-figurative abstraction conflicts with other higher con-
cepts they possess. Without this higher concept operating
in their experience they are unable to relate to the ab-
stract work as art. (See plate 2).

Insofar as the artist or spectator understands what he is
doing, he possesses concepts descriptive of that activity.
We have suggested that concepts presuppose a capacity. The
capacity a person has when he has an understanding of the
concept of art is the capacity to see the connectedness or
unity in one art activity with another. For example, it
could never be the case that only one work represented!

The problem of describing identifying features of the con-
cept of art is a formidable one. We have suggested the
notion of a formal unity which manifests itself in the ex-
periencing of the concepts in a work. The work is charact-
erized by an hierarchical patterning of higher and lower
concepts: the higher tend to reach out to other works of
art and are nourished by the existence of these concepts.
An art activity has internal coherence because it shares,
in some sense, an external unity with other works. This is
not the place to spell out the precise details of this
claim, but there is more than a hint in the intuition 'art
is made from art'.

Consider the second question: how does the concept of art
manifest itself in the experience of the pupil? We can
best approach this question by considering the related
question: What conditions must be satisfied for a pupil to
have an adequate understanding of an art activity? I sugg-
est that he must engage in it knowingly. Engaging in an
activity knowingly rather than inadvertently presupposes
the ability to describe what one is doing: and a descrip-
tion of an activity involves reference to concepts by means
of which that activity is identified and individuated.

For example, seeing the difference between turning a pot
and writing a poem depends upon the concepts we possess of
these activities. Concepts regulate our verbal behaviour
and the operations we perform on our environment. Criteria
for identifying a particular conceptual capacity vary
according to the nature of an activity. For example, using
a term correctly in a range of contexts is a necessary con-
dition for the understanding of a verbal concept, and
although a person is able to discriminate verbally, say,
between screwdrivers and hammers, unless he is able to dis-
criminate in terms of their function he has not understood
the concept. It is a sufficient condition for knowing the
concept of a screwdriver for a person to be able to use the
object screwdriver correctly. The concepts we possess then
regulate the various activities in which we engage, at
least to the extent that if we are able to correctly des-
cribe what we are doing, or exhibit in our practice that we
know what we are doing, then we possess concepts descript-
ive of that activity. The notion of exhibiting a concept
in practice as a criterion of possessing a concept has ob-
vious relevance for judging whether or not a person has an
adequate understanding of the concept of art. Before we
discuss this point in more detail below consider the foll-
owing three cases. They illustrate contexts in which the
concept of art manifests or fails to manifest itself in a
person's experience.

The first case:
"I remember an exercise given to a group of students at art
school which puzzled me immensely. It consisted in arrang-
ing and securing discarded domestic boxes, containers, and
bottlestops on a board. At the time I was unfamiliar with
the techniques of montage and I didn't understand the
point of having these techniques. Consequently I was un-
clear what I had to do when I was confronted with the task.
I knew I had to arrange the objects in some fashion, and I
had a vague notion that the arrangement must answer formal
visual criteria (e.g. those used in a shop window display!)
Since I didn't know what to do or how to go on, most of the
decisions I did make about arranging the items were quite
arbitrary. It was not until later that I began to under-
stand the convention and its possibilities (e.g. in terms
of exploring the formal qualities of the materials).
Learning to see the point of the activity involved experi-
ence of working in the medium and being with students who
did understand what they were doing. But these experiences

would not have helped if I had not recognized in experience
the concept of 'exploring the formal properties of materi-
als' as falling under the concept of art." The example ill-
ustrates the point that without higher concepts regulating
and cohering with lower concepts an activity declines into
random behaviour.

The second example provides a more positive characterization
of what we mean by having a capacity in an aesthetic con-
text. People with dress sense, for example, exhibit a ca-
pacity which marks them off from people without it, namely,
they recognize when colours or styles clash, and when a gar-
ment is out of fashion. They have a general concept of
fashion which regulates their judgement in a host of differ-
ent contexts: and they appear knowledgeable in respect of
these judgements. Wittgenstein makes a similar point about
the general framework within which the knowledgeable person
is able to give pertinacy to a range of specific judgements.

> When we make an aesthetic judgement about a
> thing, we do not just gaze at it and say:
> 'Oh! How marvelous.' ' We distinguish be-
> tween a person who knows what he is talking
> about and a person who doesn't ... Suppose
> there is a person who admires and enjoys
> what is admitted to be good but can't remem-
> ber the simplest tunes, doesn't know when
> the bass comes in. We say he hasn't seen
> what is in it.
> (Lectures and Conversations of Aesthetics
> ed. Cyril Barrett, para 17 (1966)).

The notion of a person not seeing what 'is in a work of art'
is important for understanding the concept of art. The
'montage' example above illustrates the point that although
a person may physically manipulate artistic materials in a
similar way to someone who knows what he is doing, he may
not know what he is doing! That is, he does not see the
way the activity falls under the concept of art, and there-
fore, he has no regulative principle; whereas the person in
the dress example has a principle and consequently does
know how to go on.

Thirdly, modern art presents us with examples of works
'unavailable' to us because we are unable to understand
what the artist is trying to do. That is, we can't see

what he intends in the work. Although we do not have to
know in any precise way what an individual artist intends
in a work of art, we do have to have an understanding in
general terms of the range of possibilities open to him in
that medium: and this involves having the concepts of that
activity. All art has been modern art at some time, and
the spectator has had to learn to view the work. We have
to learn the conventions and style of a period, movement,
or artist before we can appreciate what is there in the
work. For instance, we are able to understand (if we do?)
Constable, Cezanne, and Beckett because we recognize the
intentions in their work. We have learnt to recognize
these works as falling under the concept of art, and in so
doing have refined and developed our grasp of the concept
of art. Although the educated public may be able to relate
to the works of certain modernists, (e.g. Andy Worhol,
Jackson Pollack, and Anthony Caro) they may find the work
of many other modernists mystifying because they do not
have the higher concepts regulating the production of these
works.

To sum up so far, we have argued that it is conceptually
impossible to relate to a work unless we understand what
the artist is trying to do (i.e. intended in the work), and
we recognize what he is trying to do (if we do?) by seeing
what is in the work. It is because we have the relevant
concepts of a medium, convention, style, and the concept of
art that we are able to experience the features of the work
as meaningful. In the teaching context the teacher has to
get the pupil to see, hear, or notice the work in the tot-
ality of its style, period, and convention. For works of
art are objects of the sort that can only be 'known in
sensing'. Learning what the artist was trying to do and
seeing what is in the work are the same thing, and this
awareness is only gained in the experiencing of established
works. The artist's intentions are inseparable from the
concrete forms of the work in which they are manifested.
These manifestations exhibit to us the more general
features of the concept of art by means of which we are
able to see how the work relates to other works of art.

When we produce a work of art we produce it under a des-
cription, e.g. it is a painting of x, or a poem about y.
Art is intentional in the sense that it is not something
that merely happens. It is something we do, and in the
doing of it we know that we do it. Further it is a

Plate 1 'DAISY MAY' by Victor Heyfron (1961)

Plate 2 'HORACE' by Victor Heyfron (1965)

Plate 3 'TRIANGLES' by Victor Heyfron

condition of engaging in an activity knowingly, that a per-
son possesses a concept of that activity which enables him
to mark it off from other activities. For example, a per-
son reading a typed manuscript may be engaging in either of
two activities: proof reading or reading for pleasure. We
are able to make this distinction because we are able to
refer to the concepts descriptive of the two activities.
Following Wittgenstein, these concepts serve both a regula-
tive and a descriptive function. We have suggested above
that in art the concepts we have of an activity regulates
that activity rather like the grammatical rules which reg-
ulate our language use. The concepts we have of art pre-
scribes the sort of activity in which we engage and the ob-
jects we make. For example, imagine three artists present-
ed with a townscape as subject matter. Artist A tries to
get a photographic likeness of the subject; artist B tries
to convey his feelings towards his subject matter; and
artist C ignores detail and expressive qualities and con-
centrates upon the formal aspects suggested by the town-
scape (plates 1, 2 and 3 mirror these three examples).
These prescriptions are not mutually exclusive, but we can
imagine circumstances in which they were, and circumstances
in which the achievement of any of the prescriptions would
be evaluated negatively. Nevertheless, it is obvious that
each artist's practice is regulated by his concept of the
activity, and further, the specific marks that the artist
makes are linked to the higher concepts of the activity.
We have argued above that there is a conceptual link between
the specific and general concepts descriptive of art activ-
ity. For example, artist A might describe his activity as
consisting in drawing with a fine pointed pencil, attending
to detail and problems of perspective, in order to depict a
realistic representation of the local townscape. If there
is a logical connection between the concepts of an activity
and the ability to engage knowingly in that activity, then
the art educator by definition is concerned with the pupil's
acquisition of the interrelated network of concepts which
forms the concept of art. Art teaching on this argument
loosely consists in helping a pupil to develop his capacity
for formulating intentions in art and helping him to recog-
nize the intentions of others.

It is worth considering the notion of intention in slightly
more detail to bring out the points: (1) the intentions of
an artist are located in the work; and (2) formulating an
intention presupposes a capacity to do that which one

intends.

First, as observers, we recognize what a person intended to
do by seeing what he has done. We may, of course, be mis-
taken. A person's verbal report of his intentions is not
a guarantee of those intentions. For example, a pupil may
say that he intends to paint his mother, but in fact paint
his father. The fact that he painted his father rather
than his mother indicates that the verbal utterance is not
the ultimate criterion of what he intends. For in order
for us to check the accuracy of his intentions we don't
have to wait for another verbal report. We can recognize
that he has made a verbal mistake or changed his intentions
by seeing what he has done in the painting. Although the
verbal report of a person is one guide to his intentions
they are not a sufficient one, for he may always do some-
thing different from what he <u>says</u> he is going to do. Con-
ceptually, the recognition that a person is knowingly en-
gaging in a particular activity (e.g. painting) presupposes
a recognition of his intentions to engage in the activity
as manifested by what he does; and recognizing these inten-
tions presupposes an awareness of the concepts regulative
and descriptive of the activity. Secondly,formulating an
intention presupposes a capacity to do something (e.g. com-
posing a tune, painting a picture, glazing a pot).

When a person forms an intention he commits himself to do-
ing things that will bring about a certain end; namely,
that which he intends. The description of his intention
(e.g. painting a picture) indicates that which he must
achieve if he is to fulfil his intentions. It is odd to
suggest that a person is able to intend to do X, but that
he does not know in what X-ing consists. If he didn't know
anything about X-ing he would be at least committed to do-
ing something about X-ing, for example, learning to do Y so
as to do X. It is odd for us to claim that we intend to do
X in situations in which we neither believe we can do X, or
intend to do X by doing Y. Our capacity to form intentions
then, is conceptually linked to the abilities we possess or
the abilities we think we possess.

The notion of intention in art is an important one, for it
points up that art activities are not merely the spewing
forth of some mythical artistic instinct, but rather refer
to established practices; and secondly, intentions empha-
size the point that making things in art is a self-

conscious process. Work produced under the concept of art
may be unsuccessful either because the maker has failed to
realize his intentions in the work, or because the notion
of art under which a person works is inadequate.

In this final section I want to illustrate schematically
how a child may become conscious of an activity falling un-
der the concept of art. Although I have taken an example
from the visual arts, a similar sort of sequence is equally
to be seen applicable to any other art area.

At some stage, then, a child makes random marks with a pen-
cil, crayon or paint brush. The activity is undifferen-
tiated in that the child is unaware and uninterested that
making marks with a pencil is different to making marks
with a brush. Seeing that this difference matters, and
preferring one activity to another (e.g. painting rather
than drawing) is a huge step forward in the child's aesthe-
tic development. It implies that there is some dimension
on the basis of which he makes this distinction. Not just
any features will count as distinguishing one art activity
from another, for only some features will be descriptive of
the activity in which he chooses to engage. For example,
he may be able to get a likeness in a portrait with either
a thin pencil or a thick paint brush, but he may also be-
lieve that it is only by using the pencil rather than the
brush that he is able to capture certain preferred qualit-
ies. It is the concepts which regulate the production of
the work which give point to the choice of materials. For
example, the concept of art, representation, expressiveness,
loose composition, heavy lines and harsh tones all enter
into a description of the work, and all have been present,
in some sense, in the making of the work. Also, an ade-
quate description of the child's art activity requires more
than a reference to materials. It includes those features
which constitute mastery in patterning the elements of the
work, e.g. skill in use of materials, command of formal el-
ements, techniques for capturing expressive qualities and
life values.

The child's gradual mastery of an activity introduces is-
sues concerning the way he learns to attach value to an art
activity. For example, at first the child takes pleasure
in just making marks appear: then he moves on to a stage in
which he prefers this mark to that. This leads on to the
recognition that other people register approval of the marks

he makes. In turn, the child recognizes in public art ob-
jects the marks that have public approval. In connection
with this approval he forms intentions to produce these
marks rather than those. He learns not to blindly conform
to teacher's standards and evaluations, but to develop his
own distinctive viewpoint. In some sense, the marks he
makes are there because he wants them to be there, i.e.
they are the marks he chooses from a range of possibilities.
In commerce with his surroundings and the nodding approval
of his teacher he will start to produce images and patterns,
and as he increases his understanding of the elements that
make up his activity, he will learn that his activity is an
appropriate medium in which to represent things and to ex-
press feelings. However, for the teacher to be effective
in the learning context there must always be more in the
work than the pupil is explicitly aware. For if the pupil
could see everything there in the work, (i.e. its possibil-
ities) there would be nothing for the teacher to bring to
his attention. This is a logical point: and surely as
Ross (1978) suggests in 'The Creative Process' the teach-
er's role is multifaceted. Not least amongst his functions
is the need to stimulate and encourage the pupil. Finally,
the pupil learns appropriate stances to adopt before paint-
ings, and these attitudes are generalized to a range of
other art objects.

The upshot of this all too brief illustration of the child's
conceptual grasp of an art form is that an adequate under-
standing of an art activity in which a child engages de-
pends upon his increasing grasp of established artistic
practices and procedures. (The notion of 'established' is
not to be confused with 'accepted'.) I am not suggesting
that the unstructured situations in which a young child may
first be introduced to different materials and techniques
should be abandoned or that absolute standards should be
imposed on young children. Rather that the teacher evalu-
ates his own understanding of the concept of art and en-
courage pupils to acquire appropriate art principles and
concepts with which to regulate the art activities in which
they engage, and to forge their own style of response to
the elements of the art activity. This is a formal account
and the teacher will have to fill in the substantive con-
tent. What I have not discussed in any detail is the pre-
cise way that feeling and subjectivity enters into the
child's developing understanding of the concept of art. I
cannot rectify this omission here apart from suggesting

that in finding a congruence between the elements of an art
activity and an inner mental state a person registers his
preferences. And to the extent that this congruence is the
outcome of a series of intentions to produce this pattern
of marks rather than that pattern, the work asserts the
subjectivity of its maker.

> We may think of the concept of art as a
> protective parent. It is in its shadow
> that the vast oedipal conflict that is
> known as the history of art is fought out
> - a conflict in which the sons win, if they
> do, by becoming parents. Then they bear
> the concept that has borne them. Richard
> Wollheim, 'The Art Lesson' p. 151 (1973).

REFERENCES

Wittgenstein, Ludwig. (1966) _Lectures and Conversations on
Aesthetics, Psychology and Religion_, ed. Barrett, Cyril.
London, Blackwell.

Reid, Louis, Arnaud. (1976-7) Feeling, Thinking, Knowing,
in _Proceedings of the Aristotelian Society_.

Wollheim, Richard. (1968) Art and its Objects, _An Intro-
duction to Aesthetics_. New York, Harper & Row.

Wollheim, Richard. (1973) The Work of Art as Object, in
On Art and Mind. Allen Lane.

Wollheim, Richard. (1973) The Art Lesson, in _On Art and
Mind_. Allen Lane.

The Arts and Personal Growth

MALCOLM ROSS

"I know that men's natures are not so
changed in three centuries that we can say
to all the thousands of years that went
before them: you were wrong to cherish Art,
and now we have found out that all men
need is food and raiment and shelter, with
a smattering of knowledge of the material
fashion of the universe. Creation is no
longer a need of man's soul, his right
hand may forget its cunning, and he be none
the worse for it. Three hundred years, a
day in the lapse of ages, have not changed
man's nature thus utterly, be sure of
that." (Collected works of William Morris
(1977) VII, p.436.

THEORY

The Function of the Arts in Education

I want to discuss my perception of the function of the arts
in education and of the role of the arts teacher. I shall
try to present the key ideas relatively simply - examine
them in terms of particular examples where these might help
to clarify them, and speculate over possible solutions to
the problems with which I have been most recently engaged.

If we ask ourselves what do we teach the arts for, a range
of answers suggest themselves. Setting aside the special-
ised provision for the exceptionally gifted pupil inter-

ested in a professional career in the arts, we can identify
a number of objectives familiar to teachers of art, drama,
music, dance and English. One widely held view is that ex-
perience in the arts supports what is rather loosely termed
"personal development" - meaning, variously, and depending
on your own particular subject and point of view, the
building of self confidence, the development of social
skills, sensitivity towards the kinds of human issues
(timeless and contemporary) that art often deals with,
licking the rude youngster into cultural shape, civilizing
our gentlemen, and so on. I do not intend to mock such no-
tions for they are usually sincerely held beliefs and, to-
gether, they point to the conception of art as essentially
moral and socially valuable. What is less readily accept-
able because far from clear is precisely how art or arts
education has this important, transformational impact upon
young people. One senses that behind this view of arts
education hovers the notion of improvement by example or,
more simply, through benign contagion. Implicit somehow or
other is the concept of art as existing apart, created for
a spectator - art holding the mirror up to the self
than that we pass through the fire, or wrestle with the
angel until dawn and are, so, purified, initiated.

First hand knowledge and mastery of one or more of the
media or forms of art can be held to be a good thing in it-
self. It can lead to an informed interest in the arts that
will bear fruit after the pupil leaves school. At a
practical level the skills of using language, paint, metal,
fabrics, personal relationships effectively can all be
turned to advantage in real life - and a proper estimation
of the skills of craftsmanship and design and a feeling for
quality in work could be said to constitute an important
element in any concept of an educated person. Most arts
teachers attach value to the teaching and learning of
practical skills: but there is often some disagreement over
how much skill is really necessary for an adequate general
education in the arts, and as to whether skills should be
taught as an end in themselves or only strictly in the
context of their functional usefulness. There are a large
number of arts teachers who feel that their first respons-
ibility is to teach the skills of their craft - what use
is eventually made of those skills is somehow felt to be
someone else's business. The pupil's arguably.

Acquainting children with the output of artists; bringing

them to some understanding of it even affection for works
of art is a heartfelt commitment of a great many arts
teachers. Indeed it is probably what most other teachers
and most parents think arts teaching is really all about.
Which means that if you happen to find works of art inter-
esting yourself you will think that arts education serves
a useful purpose, and if you don't, that it's pretty much a
waste of time. And the skeptical will go further, pointing
to the lives of a great many artists or composers of plays
and paintings and music, and drawing the conclusion that
art is not simply useless but mad or immoral or both into
the bargain. But such extreme views do not operate signi-
ficantly to influence what actually is permitted to happen
in schools. I don't know of any instance of a child's being
forbidden by his or her parents to attend the art lesson on
moral grounds, though the issue of relevance does clearly
affect option choices when these come into operation in
secondary school. There is a prevalent and unchallenged
assumption that being able to appreciate the arts is a
good thing, and that teaching for such appreciation would
in itself justify the provision of timetable time. This
particular objective is immediately understood and teachers
whose subjects clearly afford opportunity for the apprecia-
tion of the cultural heritage fare better in the scramble
for time, space and resources than those whose subjects
don't. Again the strength of this particular principle of
art education is drawn from a perception of art as essen-
tially good - good in the sense that it celebrates uni-
versal moral values and represents some acme of human mental
and spiritual achievement. You only have to introduce the
work or ideas of more wayward artists to appreciate how
vulnerable this particular flank of arts education can be-
come.

Personal development, the mastery of specific practical and
conceptual skills, acquaintance with works of art. A
further aim of arts education that emerges more strongly
from teachers of English and drama than from teachers of
music and art has to do with what is called "self-expres-
sion". This idea is popularly associated with the thera-
putic effect of acting out one's problems, releasing ten-
sion and inhibition, having a chance to get some strongly
felt experience or idea off your chest. More subtly many
arts teachers recognise the special connection between the
arts and feelings and sense the importance of giving
children scope to express themselves truthfully, freely and

effectively through their own creative work. There are, it
would only be fair to say, a number of reservations about
this kind of work: there is some anxiety lest pupils become
over-excited or over-emotional, lest responses too personal
or too painful are accidentally triggered. Drama seems
particularly prone to run expressively riot - the line be-
tween the real and the symbolic is not always clearly drawn
or easily maintained. Traditionally, teachers of music and
the visual arts have been less inclined towards the expres-
sive aspect of arts education and have kept feeling well in
check. Nevertheless most music and art teachers would ex-
pect their pupils to achieve some measure of emotional sat-
isfaction through their work and to find evidence of the
development of personal style and individual taste.

I have sketched in this review of aims and objectives in
arts education because the particular orientation of the
Exeter projects draws in some ways upon them all. We have
given them a particular emphasis however - and, it goes
without saying, that emphasis is not by any means everywhere
accepted. The view we have adopted has been argued already
in a number of forms by writers such as Susanne Langer,
Ernst Cassirer, John Dewey, Erik Erikson, Jean-Paul Sartre,
Herbert Read, Louis Arnaud Reid. It is supported by the
work of Arthur Koestler, Abraham Maslow, Carl Rogers,
D.W. Winnicott. And the experience of many practicing art-
ists corroborates it also.

For us the crux of the matter lies in the relationship bet-
ween feeling and form. Our hypothesis is that new feel-
ings are assimilated only through projection into expres-
sive forms. Through the assimilation of new feelings our
intelligence of feeling is continually revitalised and en-
riched - we grow emotionally. The intelligence of feeling
accounts for our capacity to commit ourselves to action in
the world (it is the basis of motivation); it is through
the operation of our feeling intelligence that we discover
the emotional meaning of our experiences, that we come to
know our being and can insist upon the integrity of our own
existence. Expressive action is "subject-reflexive" - that
is to say it embodies subjective information. Every act
that follows impulse carries us into the world, gives shape
and substance to our inner reality - through such action
the self becomes actual - rather than the remaining merely
potential. In short our self-expressive behaviour is at
the root of all healthy and meaningful emotional life.

These acts are before everything else the embodiment of
feeling states: their prime purpose, we suggest, is to en-
able both maker and responder to organise and clarify
their feeling world and so to experience their feelings
with perhaps exceptional intensity. S. Giedion (1978), in
his book Space, Time and Architecture has written:

> "The opening up of ... new realms of feeling
> has always been the artist's chief mission."

This, in essence, summarises our position. Arts education
is about the "opening up of new realms of feeling" - in
the first place at the level of the individual pupil who,
through art, can achieve a sympathetic understanding of and
communion with his own subjective world; and then at the
level of the community as a whole and in terms of the
affective aspect of the times we live in. New images for
new feelings. In practice this means more often than not
providing opportunities for re-working the past, the pre-
viously experienced but as yet unassimilated emotion. It
probably also means a willingness to focus again and again,
obsessively even, upon feeling problems that spring un-
ceasingly from very depths and roots of our psychic being.
It doesn't mean the arbitrary pursuit of the novel or the
sensational. By holding onto the problematic in our feel-
ing experience (as distinct from running away from it, re-
pressing it or merely evacuating the tensions that such
problems give rise to) we achieve new levels of personal
integration. The arts offer special (though not unique)
occasions for such integration. New feelings are opened
up as they are embodied in expressive action - in acts of
forming, performing and responding. Of course we assimi-
late, integrate feeling every time we act subject-
reflexively, not just in the special province of artistic
experience but at work, at home, at leisure. The over-
riding distinction of education through the arts is its
contribution to personal growth, to the integration of the
self through expressive action. Such, at least, is our
view. In comparison with such a purpose all other possible
educational functions of the arts must seem inconsequential.
This is what distinguishes the arts from the rest of the
curriculum - this exclusive commitment to subject-
reflexive action. The development of the intelligence of
feeling cannot surely be a matter of merely marginal or
"optional" concern.

What Arts Teachers Should Be Doing

All this might be very well but what precisely should arts
teachers be doing? I think we should be precise - sweeping
generalisations will not do when we are confronted by actual
children, probably in large numbers, in real schools. Since
artistic experience is direct and immediate before all else
the first thing it seems to me that arts teachers should be
doing is engaging children in a powerful and meaningful way
as makers, performers, and, dare I say, consumers of art
now. Action that follows impulse is action spurred by the
quality of the moment, in the here and now. Of course arts
education should lay the foundations for an active involve-
ment with the arts in adulthood, but this will be the in-
evitable consequence of real engagement with the arts while
a child is still at school. Though we may not be training
children for professional artistic careers we have to treat
them as individual artists. Nor are we training profession-
al critics. Perhaps few will find their ways into galler-
ies, theatres and concert halls after leaving school.
Nevertheless while they are with us we must lead them into
rich and fruitful interaction with works of art. This of
course demands considerable insight on the teacher's part
concerning the character of artistic works most likely to
be accessible to the child's projective act. Much of the
art that appeals strongly to a teacher's own mature taste
may be well beyond the range of many of his pupils; yet,
undoubtedly, much that he loves he can share with them and
much that they love will be available to him.

Arts teachers help children express their feelings through
the making and performing of works of art - i.e. through
writings, paintings, acting, dancing and music making that
gives their feelings expressive form. They also help
children find the echo of their own inner worlds in the
images created by others and by each other, by the teacher
himself, by professional writers, painters, actors, dancers
and muscians. Doing so means attending (and attending to)
the child's developing making, feeling and perceptual
systems. It means understanding such developments and
having a sense of the stages or routes from immaturity to
maturity. It means recognising that most children are
temperamentally more attracted to some media than to
others (perhaps to one particular medium only), and that
while some children are wholeheartedly makers, others are
happier interpreting and performing, and there will always

be those for whom attending is the principal mode of ex-
pressive action. This means, if it is true, that we should
not expect every child to benefit equally from working in
all the forms of artistic action - so we should provide for
positive selection and single-minded concentration while
not discouraging those who have yet to find their medium
from wide-ranging exploration of the forms and resources
available. It also means, and this could be more difficult
both to accept and to provide for, that we wont want to
force performers to make or makers to perform, and those
preferring to watch, read or listen should be not only
allowed but encouraged to do so. Encouraged to develop
that particular expertise and avenue of expressive develop-
ment. Which means something more than equipping them with
the more objective skills of the literary or art critic.
Of course criticism need not be a mechanical nor purely a
cerebral, analytical exercise - the best critic is usually
something of a poet in his own right. What we shall be
aiming at with the child who prefers to receive will be the
maturation of the aesthetic, of his re-creative responses.
If, as seems to me, this is still relatively virgin terri-
tory in arts education, it is without question an immensely
rich one.

I have said that arts teachers need to understand the
child's making, feeling and perceptual systems, and the
steps or stages by which these systems develop. I think I
may legitimately claim that this is not the place to
attempt an account of these three inter-acting systems
which, combined, constitute an individual's capability.
I'd feel happier doing so were the claim not so transparent
a cover-up for a feeling of woeful inadequacy. To admit
the need for such an understanding is not, alas, to supply
it. All that can be said at this stage is that we are
working on it. In default of the complete statement per-
haps some tentative and disconnected observations might be
permitted.

A Model of the Expressive Process

Witkin (1974) has of course already provided us with a
model of the making system - as it applies to the relative-
ly mature operator. Creative self-expression, according
to Witkin, requires the projection of an impulse through a
medium capable of holding and reciprocating it. The

artistic process for the maker means the centring of an
expressive impulse - a mood - in a material or symbolic
form, much as a potter centres the clay upon the spinning
wheel, and then the progressive shaping of the medium into
a final form that seems more or less to "represent" (i. e.
embody) the feeling that inspired it. The precise config-
uration of the eventual image cannot be predicted since it
issues from a process of intimate interaction between what
is known and manifest (the medium) and what is unknown and
potential (the impulse). The image can only be recognised
at the moment of its achievement. The shaping process will
be by a series of approximations until the resolution of
the expressive problem is reached and the disturbance that
invariably spurs the expressive endeavour is appeased.
Witkin stresses the importance of centring the making about
the impulse: the work will never achieve resolution without
such initial centring. In practice we ask pupils to create
"holding-forms" for their expressive acts, rough sketches
that, for all their lack of refinement and completeness,
catch the stark truth, the basic sensate quality, the
essence of the impulse seeking form, and guide the process
of its development and refinement.

With group making - such as occurs in dramatic or musical
improvisation for instance - the task of centring the im-
pulse in the medium is arguably more difficult since a
group impulse must first be identified. (A group impulse
occurs as an act of transcendence - going beyond both the
possibility of dominance by individuals within the group,
or a kind of democratic sharing that allows equal weight to
the individual impulses of the members of the group while
respecting their separateness.) However, more difficult or
not, the principle is the same. Action follows impulse -
impulse is resolved and feeling redeemed through acting
upon "the spur of the moment".

We would wish to make no essential qualification of this
model in envisaging the process of creative interpretation
in the performing arts. In looking for a felt rather than
a mechanical performance, in encouraging interpretation
rather than mere reproduction we shall be insisting again
upon the importance of the maker's awareness that within
him there is an impulse seeking form. In this particular
case the impulse is aroused by the work he has to perform
- he lends himself as the medium of expression and means
of its realisation, achieving resolution by a precise

attuning of his own expressive act to the development of
the work he is mediating. For the performer too the act of
centring will be of the utmost importance. One is tempted
to say that so long as each performance eventuates in a
subtly new image it remains a creative act, an improvis-
ation. The rot sets in the minute a performer is no longer
at risk, the moment he plays safe, repeats himself, offers,
not the act of knowing but what he feels he already knows.
Teaching creative performing is in many respects like
teaching creative forming.

I have said that as teachers of the arts we must be pre-
pared to allow for those children who prefer the contem-
plative to the active mode. In practice I suspect such a
polorization would be the exception rather than the rule,
and that creative work in the studio and classroom would
move easily between doing and responding. However, it is
important just to be clear how the re-creation as it were
of forms already realized (and not, as in the performing
arts, requiring personal action by way of mediation), may
also be a way of self-knowing. If forming and performing
require the projection of an impulse upon the world of
material or symbolic phenomena, and their intelligent dis-
placement, responding to realized form is an act of crea-
tive perception involving the introjection of a form in the
world of objects as an inner structure of imagination.
Knowing a realized form means building it in imagination
for ourselves; it involves the forming of perceptual hypo-
theses concerning the deep sensate structure of the extern-
al image, progressively refining (and elaborating it) until
we sense an absolute identification with it in the fullness
of its being, and the consequent flowing or clarification
of our itensified feelings in respect of it. Adrian Stokes
(1972) has written marvelously about the experience of re-
sponding to works of art and in an essay entitled The
Luxury and Necessity of Painting he makes the following
point:

> "The great work of art is surrounded by
> silence. It remains palpably "out there",
> yet none the less enwraps us; we do not so
> much absorb as become ourselves absorbed.
> This is the aspect of the relationship, held
> in common with mystical experience, that I
> want to stress, because the no less import-
> ant and non-mystical attitude to object

other-ness in aesthetic appreciation has
been better admitted".

We have to find a way of allowing the image to penetrate us,
and to organise our being, answering a call we didn't know
we had uttered, a question we hadn't asked but needed to
ask and have answered. Penetrating to the heart of a real-
ized form means submitting to its power to possess us and
to re-order our inner world - it is perhaps rather less pen-
sive than it sounds since it requires intense activity on
the part of our intelligence of feeling, creating a subject-
ive correlative for the object that confronts us. Such an
account of artistic appraisal or appreciation may seem a
far cry from the familiar school activities that pass as
such.

The Representational Crisis

I would not want, at this point, to be pressed too closely
over the applicability of this model to children of all
ages. Whereas I am now entirely convinced that this account
of the process of creative self-expression adequately des-
cribes what creative artists do, and, by inference can be
used as a model for older children, my guess is that we
probably need not so much a different model as a change of
emphasis where younger children are concerned. There's a
very important watershed in the development of a child's
representational behaviour that occurs around age seven.
We might be inclined, if we were of a sentimental dispos-
ition (and I know I am), to say it is the moment when in-
nocence is lost - the shift from an innocent, unselfcon-
scious engagement with one's own experience and the per-
ception that experience can be frozen, framed, stood back
from, re-worked, falsified, enhanced. That representational
action can be separated from the act being represented. I
am describing the child's realization that he can make (and
own) works of art.

Adults very often treat children - especially in school -
as if they were already aware of the facts of art. I'm
sure we shouldn't. We all very well know that, free from
adult pressure, young children are not self-conscious about
their representational play. Drawings and paintings for
instance up to a certain age are often wholly un-selfcon-
scious affairs, created without regard to adult conventions

of picture making and purely for the sensuous, imaginative
and probably dramatic delights to be had at the time of
making. The resulting image is more a record of the pro-
cess than an achieved symbol of personal experience. The
"maker" may be quite unimpressed by the artefact he or she
is left with - adults, however, often find these strangely
direct and unique images marvelous in their simplicity,
power and integrity. Certainly they evince a marvelous
natural feeling for the representational power of the
materials - a faultless confidence very often in being able
to say what you want to say. A confidence that derives
from the nature of the representational act - from the
child's "not intending art". What Witkin calls "the repre-
sentational crisis" occurs with the realization that pic-
tures are for framing, hanging or sticking on the wall;
that they can be separated from the here and now, from
being and from doing, and esteemed by other, more remote
criteria. That they have a life of their own - as symbols.
These criteria are not simply remote from the child - they
are beyond comprehension until he reaches a certain point
in his development. That is why I feel we should be ex-
tremely careful how we treat and how we value the products
of children's creative play. With the dawning of the idea
of art comes the greatest threat to subject-reflexive
action. Confidence is suddenly lost as the new criteria
are invoked. The child senses his inadequacy in relation
to the adult conception of art and unless he can be carried
by some St Christopher across the flooded water meadows of
innocence onto the uplands of experience we all know he
will lose the nerve to give form to feeling, perhaps
irrecoverably. The representational crisis calls for in-
tensive care by the teacher for the child. How many
teachers have been trained or have learned to cope? Cer-
tainly not enough. Most of us are aware of the problem but
we don't, on the whole, understand it, nor do we have the
resources to resolve it.

The model of the creative process could help here - part-
icularly the idea of the "holding-form". Children at this
subjective crisis point turn, perhaps instinctively, to the
world of objects - their work in the arts becomes markedly
object orientated. They want to imitate and reproduce what
they see, what they know, as exactly as may be. Because
they want to know the world of objects. By using the
stratagem of the holding form it may be possible to keep
the affective element alive at the moment that it is most

threatened. To become conscious of art is to become con-
scious - self-conscious - about feeling. Older children
are tempted either to run from the expression of feeling
altogether (and for ever) as childish (and therefore con-
temptible), or to reach for the well tried feeling formulae
of the adult world. In either event their work loses au-
thenticity - they fake it and soon become convinced that
faking it is what it's all about, which means it's a waste
of time. For the pre-crisis child the model is perhaps too
elaborate - feeling finds form instantly; the image grows
organically and unawares. It is both means and end: both
sign and symbol. The cleansing of the doors of perception,
the clearing of the channels of feeling - both absolutely
critical responsibilities of the teacher of the arts - can-
not be usefully conceived of outside the field of aesthetic
action that I have been describing. Perceptual and
emotional development would seem to be intimately linked
from the very beginning of life experience and there is a
sense in which to speak of one is also to speak of the
other. It is not for nothing that the word "feeling"
applies to both physical sensation and emotion, or that in
the idioms of popular language we have an untold number
instances of physical experiences standing for emotional
ones: we speak of having butterflies in the stomach, aching
hearts, bitter thoughts, bright ideas. Because the origin-
al Project concentrated especially upon the experience of
the adolescent we paid particular attention to the aesthetic
developments occuring at that time. In the final chapter
of "The Intelligence of Feeling" Witkin offers the suggest-
ion that a new level of perceptual/affective skill is
evident in the behaviour of the adolescent.

> "As a first crude approximation to a scheme
> for analysing sensate development, I will
> distinguish between the pre-adolescent
> phase in which symbol and object world are
> still tied to one another and in which
> symbolic organisation does not therefore
> assume a holistic form, and the adolescent
> (and post-adolescent) phase in which symbol
> is progressively freed from object and be-
> comes independently organised to 'absorb'
> the totallity of sensate experience in its
> domain. " (p.177)

On page 179 he continues by saying that adolescent and

post-adolescent representation involves "ordering sensate
experience at the level of the sensate totallity. It is
ordering in respect of 'wholes' rather than ordering be-
tween individual sensate events." Essentially, the some-
what crude devices that were entirely adequate for ordering
the sensate experience of childhood yield now to much more
sophisticated ones. The possibility therefore exists for
representing the new range of perceptions that are the
fruits of the maturation process. Readers of <u>The Intelli-</u>
<u>gence of Feeling</u> will recall the two sets of structural
categories.

Pre-adolescent:	Post-adolescent:
Contrasts	Polarities
Semblances	Identities
Harmonies	Syntheses
Discords	Dialectics

This is an important insight - one that further strengthens
the teacher's capacity for dealing with the representational
crisis, for carrying the boy or girl over into the world of
experience and yet preserving the kernel of innocence that
lies at the heart of every authentic artistic act.

PRACTICE

So much for the conceptual model: if it has any value it
lies in the impact it has upon teacher practice. Hopefully
it will inform teacher action by indicating the critical
points of the expressive process and of expressive develop-
ment and by giving rise to speculation about how the diffi-
culties may be met and the possibilities realized. Teachers
of the arts have not always found it easy to enter into the
child's creative act - to counsel from within. Unless you
know where the child is or where he is headed how can your
advice be anything other than hit or miss - and, given the
enormous influence teachers can have over children's atti-
tudes, values and behaviour, it is not hard to see how
damaging misinformed or inappropriate advice can turn out
to be. If we are to intervene, to say anything at all (and
many teachers, recognising the difficulties, prefer to say
nothing or to offer merely factual information and technical
know-how), it has to be on the basis of relevant information.

We also have to know when to remain quiet, when to apply
pressure, when to call a halt, when to admit that we just
don't know either. I hope it may be helpful if, by way of
conclusion, I take a brief look at some of the practical
implications of which I have been saying.

The Isolation of the Arts

In the first place it seems sensible to do something about
the isolation of the arts in school. From what has been
said it surely makes sense to conceive of education through
the arts as a single-minded activity. If we could accept
that what matters for children as a whole is what the arts
subjects have in common, while acknowledging that what mat-
ters to individual children very often is that the arts
are all different, then it might be possible for arts
teachers in a school to speak pretty much with a single
voice, to be on the lookout (to put it at its least pos-
itive) for occasions of talking with each other, sharing
experiences, combining classes, of agreeing a common set of
aims and objectives and a common approach to assessment.
In short to present a coherent educational programme not
just to the pupils, but to the Head, fellow teachers,
parents, governors, students, inspectors and interested
visitors. I cannot see that there need be any serious loss
of autonomy, crisis of identity or threat to personal free-
dom in such developments. The greatest barrier to this
kind of thing (it _is_ happening but is still very much the
exception rather than the rule) is not the timetable, nor
lack of material resources as we are often told. It lies
in the entrenched commitment of the trained arts specialist
to the mystery of his craft, to esoteric knowledge and a
highly forbidding technology. To the cult of the guild.
It is wrought in him through his own training which, in
many cases could hardly have been less appropriate to what
is needed if he is to be able to operate as a teacher in
some of the ways we have been considering.

The Creative Arts Teacher

Whether he works alone or with others the teacher dedicated
to creativity in the arts will have to create the necessary
and appropriate conditions. This may be harder than one
might think when one considers the largely uncreative (to

say nothing of the largely unfeeling and uninvolving) cur-
riculum with which most secondary and all too many primary
school children have to reckon. Children soon learn that
schooling is an experience all its own - at best something
to turn to advantage, at worst something to protect oneself
from. In a recent cartoon (The Observer, Sunday 8th July
1979) Jules Fieffer suggested they "build anti-bodies". If
this caricature is not entirely wide of the mark it serves
to indicate something of the problem facing not just the
educational innovator but the arts teacher whose work de-
pends absolutely upon children being prepared to take him
seriously and seriously (even joyfully) to commit them-
selves. I have written at length elsewhere about the idea
of the 'good enough' teacher, about the strains inherent in
the creative process and the need for a protected and pro-
tecting environment in which the self is to hazard itself
upon uncertainty and in blind faith. Creating the con-
ditions of creativity means

1) establishing the sanctity of mutual truthfulness
2) developing trust (trust worthiness and trustfulness)
3) being free enough to free students to act playfully, to
 explore and invent in an atmosphere that is non-judg-
 mental, where error is essential to trial
4) providing conditions of psychic safety - being com-
 passionate
5) being devoted to the child's learning and growth.

Evidence that the necessary conditions obtain would be a
student's openness, tolerance of ambiguity, freedom from
inhibition; his or her artistic self-confidence, intrinsic
motivation and strong self-evaluation; a readiness to play
and experiment, to improvise and speculate with ideas,
material and symbolic elements. Where the kind of behav-
iour is lacking one can only draw the conclusion that some
of the pre-conditions listed above have not been met. Of
course individual children will differ greatly in respect
of these pre-conditions, some finding it relatively easy to
be trusting and to feel secure, others having enormous
problems in overcoming their inhibitions. Particular
children's needs may change over time - most young people
experiencing the trauma of the representational crisis for
example and, as we have seen, demonstrably in need of more
intensive care at that time. Needing also perhaps a re-
direction in their work that would leave them less vulner-
able, less exposed. As I have said if you want to know

whether the conditions are right you only have to look at
what is actually happening. Diagnosing precisely what is
going wrong may be a more awkward matter since children are
subject to pressures wholly beyond your control (pressures
at home, in their private world, from elsewhere in the
school) - and it is not always possible to set up a situ-
ation wholly detached from such disabling influences. It
is, of course, lamentable that at times one has to try to
do just that.

The Expressive Curriculum

From here on I am going to have to be more personal - in
the sense that I shall be drawing rather more on the par-
ticularity of my own teaching experience and shall there-
fore have to take a less dogmatic stand. I should like to
think that the teaching process I shall outline (there's
not time for more than a sketch here) is not, however, en-
tirely bizarre and wholly foreign to the experience of
other arts teachers. I say "arts teachers" because I am
neither thinking of nor dealing with single artistic
disciplines but with the whole range of expressive media
and forms. I shall also be confining myself to a consider-
ation of expressive work on the "practical" side of the
representational divide.

The expressive process has four discernible phases

1) locating the expressive impulse
2) connecting with a suitable medium
3) realization of feeling in form
4) verification.

Getting Going

Getting expressive work going may be no bother at all - the
prospective maker or responder may already be in an express-
ive mood, may have feelings already seeking form, in which
case you move with all speed directly into the active phase.
But more often than not a class or an individual doesn't
know what it wants to do, and although there are arguments
for leaving them floundering or to seek their own salvation,
there are certainly times when one would wish to help quite
positively. On these occasions I opt for one of two

approaches. Both amount to de-limiting the possibilities.
I might, for instance, suggest a doodling activity: by this
I mean an immediate engagement with a medium, a technique
or a group of realized forms that is pure play. The as-
sumption behind this approach is that beneath the surface
of consciousness our feelings lurk in the shadows like vor-
acious pike, ready to pounce upon the merest possibility of
expressive satisfaction in form. The doodling initiates a
form of relaxed perceptual scanning that eventually detects
the possibility of affective centring - it could be that
some happy accident of movement catches the imagination, a
configuration of line or a disposition of colours. Perhaps
a cluster of notes, a rhythmical pulse, a phrase or movement
of speech. Before we know where we are we are hooked and
begin to develop the possibility of clarifying and deepening
feeling through the full realization of the formal possi-
bilities we have glimpsed. Essentially this means allowing
the maker to decide upon his own expressive task and very
often the best way is simply by the taking up of a medium, a
tool or an image that will offer immediate satisfaction and
pleasure. The implication is of course that the maker and
I know what his tastes in these matters are, or might read-
ily become. Doodling is the oblique approach: what
Igor Stravinsky in his book "The Poetics of Music" calls
'kneading the dough'.

Such work - indeed all expressive work - must be authentic
in terms of the student's somatic identity - and we aught
perhaps to give more time to defining it. Above all to
seeing that the student defines it: finds his own line, his
own key colours, his signature in sound and movement. This
is the basis of authentic style - a personal voice. I al-
ways have this continuing act of self definition in mind in
all expressive work.

A more direct approach, and one in which I am more clearly
"in the know" from the outset since I am in a sense setting
a very specific problem, is to use a sensate theme. I
might simply suggest that work be begun upon such-and-such
(naming the theme), or, leaving the concept to one side,
choose some more imaginative means of arousing a response
that will in effect evoke the sensate ordering I have in
mind. I choose my themes on a principle I am currently
trying to develop and test. In a nutshell: it seems poss-
ible that there are only a handful of root or deep psychic/
feeling structures available to us for ordering emotional

experience. These are the same for everyone though we each
use them in our own ways, emphasising some at the expense
of others and creating unique sets of affective forms or
schema. This limited repertoire of inner affective struct-
ures is matched by a similarly limited range of objective,
expressive or aesthetic structures. I am tempted to pursue
this idea because something similar has been going on for
some years in the fields of linguistics, and of the phys-
ical and natural sciences. My "basic forms" comprise the
following two pairs

Reaching (branching) branching out: Covering (shells) go-
ing into ones shell

Taking in (spirals) grasping, getting a grip of: Giving
out (exploding) releasing, voiding.

The essence of each of these paired structures is that they
stand at the root of a whole family of feeling experiences:
that they suggest objective correlatives (shapes or forms);
and that they are fundamentally enactive - images for/of
human action. The structures are in themselves affectively
neutral. That is to say, depending upon the circumstances,
they can be felt as pleasure or distress by the one experi-
encing them. In terms of felt experience they can equally
give rise to active as to passive experience: I can "do"
the doing or "suffer" it (I can reach or be reached, pene-
trate or be penetrated). Setting the problem to a student
simply means establishing the expressive possibilities of
the deep structure for him as a means of particularising
his own emotional experience.

The advantage of this approach over the doodle is that the
teacher knows the sort of form to be on the lookout for.
With the doodle he has to use all his sensitivity to dis-
cover the basic structure the student has intuitively de-
cided to work with - you have to be able to grasp the sen-
sate problem, sometimes before the student does. Until you,
the teacher, have indeed "grasped the sensate problem" that
lies at the heart of the expressive task you are not in a
position to be of significant use to the student.

I am also experimenting with another conjecture: namely
that aesthetic responses are essentially of three kinds,
that these represent stages of aesthetic development and
account for all forms of expressive activity. In practice

this means I am likely to choose one particular activity
rather than another for a student depending upon my esti-
mate of his stage of aesthetic development, his current
disposition and preoccupations. Perhaps I should say a
word or two about this idea.

Kandinsky (1977) in "Concerning the Spiritual in Art"
identifies three different sources of inspiration for his
own work. When he is especially interested in some quality
of the object world and seeks to represent or imitate
nature he calls his creations Impressions. As we have seen
already young people negotiating the representational cri-
sis turn for reassurance to the world of objects - they
seek to imitate or represent that world in all its sub-
stantiality, true to their perception of it. This natural
inclination, readily discernible in their creative work,
should be endorsed. The period of late childhood or early
adolescence could be called the Period of Impressions.

Kandinsky notes next what he calls his Improvisations.
These are close to what I have called doodling - it is a
media-dominated activity in which the expressive qualities
of a medium are played with and exploited almost entirely
for their own sake. Possibility and the transcendence of
mere impression-taking is the nature of this new game: it
is highly characteristic of middle adolescence when the
earlier insecurities have been assuaged and the full mean-
ing of his new power of creating his own realities through
personal symbols is slowly dawning upon him. He moves in-
stinctively into a period of decoration and "effects",
looking for new formal possibilities, testing media in ways
that would have been impossible earlier in his aesthetic
development. This, the period of adolescence proper, is
the Period Improvisation.

The third category used by Kandinsky to describe his own
work is Composition. By this he means a noted and especial
emphasis upon the considerations of form and structure as
content. Again, looking at the work of children in school
it is possible to detect another shift of interest in late
adolescence, one that signals the arrival of a fully mat-
ure artistic sensibility: it is this very concern with the
formal and structural possibilities inherent in image mak-
ing and available to critical appraisal. Perhaps we might
be permitted to borrow this third term and using it in
this rather special sense speak of the period of late

adolescence and aesthetic maturity as the Period of Composition. It is preceded as I have already suggested by a period of improvisation which is in a sense a transitional phase - a bridge between the impressive and the compositional phases.

I am not suggesting that these are characteristic features of aesthetic experience which we progressively grow through and out of. Far from it. I think they probably do lead on from simpler to more complex forms, from concrete to abstract, but individuals will tend perhaps to feel more at home with one than with the others, with impressions for instance rather than improvisations, and will concentrate their efforts in that particular form. Others will wish to move freely among them (Kandinsky did) or revisit each in turn as the spirit moves. However that may be I find it useful to have these categories in mind when working out a programme for a particular group or an individual student. Those responsible for teaching classes of adolescent children might like to see whether focussing work in these three different ways were of any help in carrying through a programme reflecting the process of aesthetic development. One senses that very few teachers take much account of the idea of aesthetic development as such in planning their programme. It could be that they don't feel significant changes of kind rather than say degree or emphasis do actually occur; perhaps they prefer to rely upon intuition rather than concept in allowing for aesthetic growth. Maybe the problem is - as I tend to feel - that they don't have a conceptual model of aesthetic development to work to. I find it difficult to believe that our work in the arts couldn't be much sharper, much better directed and much more effective if it were articulated in terms of a theory of aesthetic development. Without such a theory our assessments and curriculum decisions must continue to lack real authority. I have dwelt at some length upon the initiating phase - I sense that I have been led to take up a number of issues not strictly germane to the locating of the expressive impulse but rather of implicit concern for the creative process as a whole. No matter: it means I can probably be relatively brief in my treatment of the remaining three stages.

Grasping the Problem

Grasping the core of the expressive act is, as I have already indicated, a matter of sensing that the impulse is firmly at the centre of the response - whether it is forming, performing or attending. The subject (maker, performer, audience) will know in their bones. The teacher has to read the signs and take account of whatever other evidence is available, reliable and relevant. Consulting the pupil will, of course, be of the utmost value and careful probing through discussion can help to clarify the problem in hand for teacher and pupil alike. On the other hand the pupil may not be adept enough at self-reflection and self-presentation to be of much help. The teacher has above all the evidence of the emergent form. Grasping the sensate problem means classifying its deep structure and testing that this is essentially the form the pupil needs to work with. There will be other questions too - such as whether the pupil is working in the right medium - right, that is, for him, now, saying this particular thing. For the pupil, grasping the sensate problem is the moment of inspiration when feeling for the work in hand becomes focussed and directed, when he feels a sense of confidence at the prospect of a happy resolution, when he senses he knows what he wants to say because he has grasped how it could be said. Playfulness and puzzlement yield to a perceptible mood and at one in the same time one senses the call of the impulse and hears the answering voice of the medium. All is not clear yet however - the impulse is still only sensed. Not until the equation between feeling and form has been completely worked out will the feeling finally clarify and flood being in full intensity. That is the moment of realization, of resolution, of insight. It is the moment of access to a new realm of feeling as the unknown is finally linked in the realized form to the known. Works of art are connections, circuit junctions in the field of affect. They literally permit the flow of feeling in new directions. Making the connection is what solving sensate problems is all about - it is the function of expressive action.

Resolution and Verification

The progress from impulse location via the grasping of the problem to its resolution may take hours, days, weeks - a lifetime even. On the other hand there may simply be a

blinding flash of inspiration and the whole process com-
pleted without pause for breath. There just is no knowing.
What we do know, and can account for with confidence, is
the general character of the process - which means that
both teachers and pupils can find their way when the situ-
ation becomes confusing and may avoid making gross errors
of misjudgment that could cause the unnecessary abortion or
distortion of the project.

Verification is the term I am using to cover the final ex-
periencing of the outcome - of the forming, performing and
attending processes. It amounts to a testing of the out-
come in terms of a new level of being. Does it work? Is
it true? Is it honest? Does it proclaim life? These
kinds of question are the significant ones. Perhaps I
should just say that I don't always expect to like what a
student has done. I do, however, expect to be able to cor-
roborate its truthfulness, to agree with the student's own
verification. But my mind is usually moving ahead. Re-
viewing the progress of this now completed work I have all
the while been looking for the clue that will tell me what
next needs to be done. I must then compare my assessment
with the student's - and be prepared for his knowing better
than I do. If verification is about one thing more than
anything else it is about being moved. "Stirred", as
Martha Graham put it recently.

The Good, the True and the Beautiful

But not just stirred, one is tempted to say. Stirred of
course, but stirred to a perception of the good, the true,
the beautiful. For art, and the works of art, are about
transcendence, about the achievement of new perspectives,
the cleansing of the doors of perception. The experience
of art may often be disturbing, even disruptive, painful
and threatening - artists were never easy bedfellows of the
establishment. But the tendency of art - again, to cite
Kandinsky - is onward and upward. It is ultimately inte-
grative; it bids us left our eyes to the hills. Herman
Hesse (1972) has this lovely passage in his book "The
Glass Bead Game".

> "The poet who praises the splendours and
> terrors of life in the dance measures of
> his verse, the musician who sounds them in

a pure, eternal present - these are bringers
of light, increasers of joy and brightness
on earth, even if they lead us first through
tears and stress. Perhaps the poet whose
verses gladden us was a sad solitary, and
the musician a meloncholic dreamer; even so
their work shares in the cheerful serenity
of the gods and the stars. What they give
us is no longer their darkness, their
suffering or fears, but a drop of pure
light, eternal cheerfulness. " (p 295)

I am convinced that we have to assert the moral courage of
the artist and the essential vitality of the expressive im-
pulse when we have to defend the cause of the arts in edu-
cation. And I begin to feel that cause can never be safe,
that it will always need fighting for. William Morris was
such a fighter.

Education through the arts is education for personal know-
ledge, self-awareness, and the growth of imagination and
perception. Above all it is about the development of an
intelligence of feeling. The procedures I have described
have led some people to label the expressive approach thera-
putic. In saying so they usually intend some disparagement
as if therapy were only needed by those who in some way -
physical, psychological, social, moral - don't come up to
scratch. They caricature the idea of self-expression as
self-indulgence - the possible beneficial cathartic release
of tension. In as much as therapy and education have a
common commitment to personal growth, to the process of ma-
turation, to the assimilation of experience and eventual
personal fulfilment that I don't demur. I doubt whether
any of us ever quite comes up to scratch. But I am not
talking just about letting off steam or taking it out on the
canvas. Subject-reflexive action is a brave (because risky)
commitment to probe the cloud of unknowing that obscures
one's inner world - a commitment constantly to take issue
with the angel in the night and wrestle if necessary until
dawn. Above all to prevail. Which means that innocence is
not enough. We may well look back (or sideways) enviously
to the direct, uncomplicated work of children and the men-
tally or emotionally disturbed, admiring the innocence, the
power and above all the purity of their expression. But
childish things are to be put away; madness is, if not al-
ways, then very often, growth thwarted, stunted or

distorted. The arts must "mean", eventually, in the con-
text of a full and healthy adulthood - we must be able to
dream with our eyes open. Because we desire it and command
it of ourselves. I believe Kandinsky right in proclaiming
the spirituality of art. Man's heroes are weavers of energy
which is why we worship them. The call of art has always
been to act heroically - to resist the entropic drift: to
harness the energy of the inner world for the enlightenment,
enrichment and goodness of mankind. The failure of art, the
failure of arts education, spells spiritual disaster.

REFERENCES

Giedion, S. (1978) Space, Time and Architecture. Harvard.

Hesse, Hermann. (1972) The Glass Bead Game. Harmondsworth,
 Penguin.

Kandinsky, Wassily. (1977) Concerning the Spiritual in Art.
 Dover Publications.

Ross, Malcolm. (1975) Schools Council Working Paper, 54,
 The Arts and the Adolescent. London, Evans - Methuen.

Ross, Malcolm. (1978) The Creative Arts. London, Heinemann.

Thompson, Paul. (1977) The Works of William Morris.
 Quartet Books.

Witkin, Robert W. (1974) The Intelligence of Feeling.
 London, Heinemann.

Wollheim, Richard. (1972) The Image in Form, Selected
 Writings of Adrian Stokes. Harmondsworth, Penguin.

Author Index

Subject Index

121

problems 100
Form 7
 basic forms 113
 expressive 86
 and feeling 99
 holding 103, 106
 of medium 4
 perceived 7
 realized 104, 116
 as structure 114
Forming 100, 101, 104, 106
Growth, personal 97, 118
Humanism 39, 51
Image 57, 103, 106
 self- 34
 making 114
Imagination 52, 104
 and the arts 44
Imagining 11, 52
Impressions, period of 114
Improvisation, period of 114
Integration, personal 100
Knowing 10, 11
 in doing 90
 how 20
 that 20
Knowledge
 about 16, 64
 academic 16
 high-status 20
 of 12
Leisure 61, 62
Making, of art 6, 13, 52, 101
Meaning 1
 aesthetic 4, 6, 7
 in the arts 1, 90, 119
 conceptual 4, 5
 -embodied 3-5, 8, 10-14
 expressed 6
 imaginal 5
 intrinsic 8
 personal 2
 poetic 5, 6
 presented 6
 referential 2, 7

symbolic 7
symptomatic 2
value 10, 11
Medium
 in art 55, 90
 control of 97
 of expression 4, 94, 102, 103
 working in a 6, 88, 101, 102, 112, 116
Montage 88, 89
Music 7, 8, 12, 56, 72
 elements in 8
Painting 6, 7, 84, 93
Pattern 85
Perception
 of form 7
 of formed content 11
Perceptual
 development 107, 108
 system 101
Performing 100, 101, 103, 104
Play 112
Poetry 5, 6, 9
Power
 personal 63, 66, 67
 social 67
Projection 101, 102
Race 30
 multi-racial society 31
Racism 35 35
Rastafarian Movement 34
 arts 34
Rationalism 43
Religion, and culture 38
Representational crisis 105, 106, 110
Ritual
 in ethnic minorities 32, 39
 in schools 17, 18
Sacrament
 labour as a 38
 sacramental vision 43